IMAGES
of America

HERTFORD COUNTY

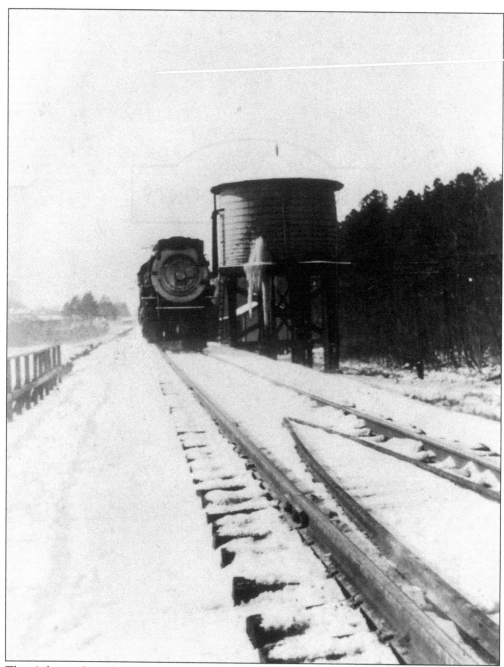

This Atlantic Coast Line steam engine taking on water at Tunis in the winter of 1936.

(*cover photograph*) An 1898 photograph depicts Chowan College president John C. Scarborough and a group of students in front of the Columns Building, which remains in use today as the college's administration building.

IMAGES
of America

HERTFORD COUNTY

Frank Stephenson

ARCADIA
PUBLISHING

Published by Arcadia Publishing
Charleston, South Carolina

Library of Congress Catalog Card Number: 2003107431

For all general information contact Arcadia Publishing at:
Telephone 843-853-2070
Fax 843-853-0044
E-mail sales@arcadiapublishing.com
For customer service and orders:
Toll-Free 1-888-313-2665

Visit us on the Internet at www.arcadiapublishing.com

This book is dedicated to my three children, Eugene F. Stephenson, John L. Stephenson, and Caroline F. Kuenstler, and my two grandchildren, Marlon Jakob Kuenstler, and William Franklin Stephenson.

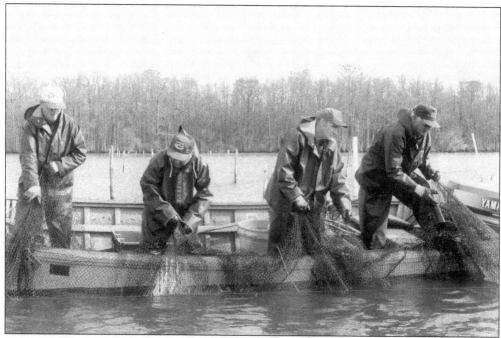

Herring fishing has a been a part of life in Hertford County for many years. A pound-net fishing crew from Tunis Fishery is seen fishing in the Chowan River.

CONTENTS

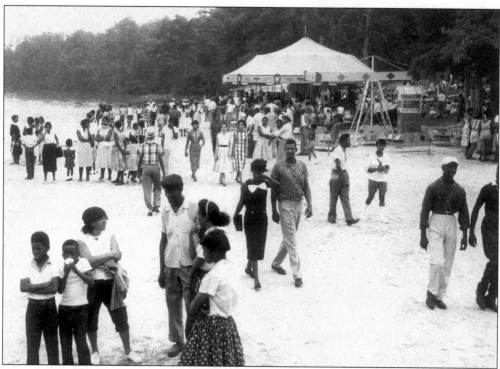

One of the great East Coast African-American beaches, Chowan Beach was located in Hertford County about a mile above Winton on the Chowan River. This black resort was started in 1926 by Eli Reid who operated it until 1968 when he sold it to Sam Pillmon, who operated it into the early 1990s. This is a July 1958 photograph.

ACKNOWLEDGMENTS

Mrs. Alice Nickens, Winton, North Carolina
Mrs. Shirley Whitehead, Como, North Carolina
Mrs. Addie Myrick, Como, North Carolina
Mrs. Barbara Mulder, Conway, North Carolina
Mrs. Mary Etta Flowers, Murfreesboro, North Carolina
Mr. Joseph M. Parker, Raleigh, North Carolina

INTRODUCTION

When the sun rose along the coast of what is now North Carolina on that eventful day in July 1584, neither the Englishmen aboard the two ships anchored off-shore or the native Americans a short distance away on land could have known that when they were to come together, face to face, that this link in a long chain of events would forever change the history of the world. In a report written by Capt. Arthur Barlow to Sir Walter Raleigh concerning the first English attempt to settle Roanoke Island, North Carolina, he made reference to the area that is now Hertford County. The 1584 colony failed and a second attempt was begun a year later with Ralph Lane as the governor of the English colony at Roanoke Island.

Even though the 1585 colonists were based on Roanoke Island, they made a series of expeditions up the nearby sounds and rivers. One such expedition, under the personal command of Gov. Ralph Lane, came up the Chowan River and explored part of what is now Hertford County in the area between Parker's Ferry and Winton, which at that time was a part of the Native-American province of Chawanook. In 1622, some years after the failed attempts to establish a settlement on the Outer Banks of North Carolina at Roanoke Island, a party from the Jamestown settlement explored the region now known as Hertford County. This followed earlier attempts in 1608 and 1613 by Jamestown explorers to search in the Chawanook country of Hertford County for any survivors from the ill-fated settlements at Roanoke Island. None were ever found in Hertford County or elsewhere and the fate and location of the survivors of the colony remains a mystery today.

Finally in 1759, Hertford County, named in honor of the Marquis of Hertford, Francis Conway, was officially formed and thus began the saga of a remarkable county and its diverse population of European Americans, Native Americans, and African Americans. This rich cultural heritage is what makes Hertford County one of the more interesting and intriguing counties in the United States. This great North Carolina county is the birthplace of Dr. Richard Jordan Gatling and the final resting place for Harriet Beecher Stowe's grandfather Eli Foote and William Hill Brown, the first American novelist. It gave the nation a kaleidoscope of wartime heroes, inventors, educators, physicians, and statesmen, as well as the town of Murfreesboro, which is the mother city of Murfreesboro, Tennessee and Murfreesboro, Arkansas.

Two of Hertford County's war heroes were Col. Hardy Murfree, who was the hero of the Battle of Stony Point, New York, and Gen. Joseph F. Dickinson, who was a hero in the War of 1812. The ravages of war did not escape Hertford County as it is one of the few, if not the only, one in the United States to have four towns burned during war. All four towns were located along the Chowan River in eastern Hertford County. Two—Wyanoke and Maney's Ferry— were burned during the Revolutionary War, while Winton and Bartonsville were burned during the Civil War.

Hertford County's economic life has always been linked to the soil, with such field crops as peanuts, tobacco, cotton, corn, and soybeans. Forest products such as lumber, pulp wood, barrell staves, and tar were important in the early development of the county. Some of the best peanut-growing soil in the country, Norfolk sand loam, can be found in Hertford County. Ahoskie's

huge tobacco market played a major role in the economic and farm life of the region but sadly it is no more as it closed several years ago.

Education and culture have played a prominent role in the enlightenment of Hertford County's citizens, particularly Chowan College and Wesleyan Female College in Murfreesboro. Chowan College, founded in 1848, remains strong today while Wesleyan suffered two major fires and was not rebuilt following the second one that occurred in 1893. Later in 1967, the transformation of the North Carolina prison unit at Union into Roanoke-Chowan Community College expanded the collegiate education opportunities for Hertford County citizens. Public high schools such as Ahoskie, Harrellsville, Murfreesboro, R.L. Vann, C.S. Brown, and Como were supported by a host of elementary schools scattered throughout the county, including 10 Rosenwald Schools. Waters Normal Institute in Winton, founded by Dr. Calvin Scott Brown, played a prominent role in the education of blacks in the county. In 1966 the conversion of the Richard Theatre in Ahoskie into the Gallery Theatre has provided Hertford County and the region with first-rate live theatrical shows and productions performed mainly by local talent.

Life in Hertford County has always been heavily influenced by the numerous waterways within or adjacent to its boundaries, including the Chowan, Meherrin, and Wiccacon Rivers and Potecasi, Liverman, Buckhorn, Hare's Mill, Catherine, Ahoskie, Turkey, Chinkapin, Swain's Mill, Stony, and Indian Creeks. Swamps such as Ahoskie, Cutawhiskie, Bear, Flat, Hoggard, Killian, and White Oak had a bearing on life in Hertford County, particularly in the early years.

While Ahoskie and Murfreesboro are the larger towns, Hertford County's diverse culture and heritage also can be found in smaller communities such as Mapleton, Winton, Harrellsville, Como, Tunis, South Tunis, Riddicksville, Poor Town, Earley Station, Pleasant Plains, Bethlehem, Archer Town, Menola, St. John, Union, Cofield, and California. This and much more makes Hertford County, North Carolina truly a place in the heart.

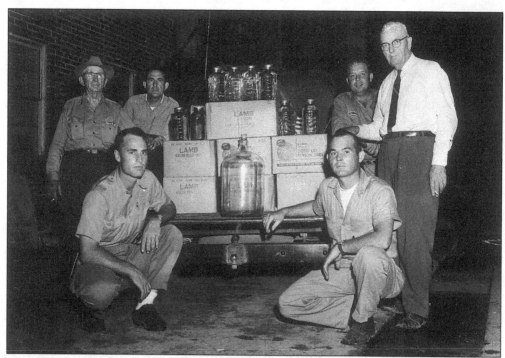

On July 15, 1959 Hertford County sheriff Charles Parker, in the white shirt, and deputies Jim Mitchell, Fred Liverman, James Baker, Leon Perry, and Winton police chief Thomas Pope pose with moonshine they seized that day near Harrellsville.

One

EARLY YEARS

When the first European settlers began moving into what we we know today as Hertford County, they faced a gigantic task of trying to carve out a home in a rugged area that was swampy, laced with rivers, creeks, and branches, and was anything but hospitable. Transportation as such was primarily by water or following paths made over centuries by Native Americans. Some of the Native American paths would later become the routes of today, particularly in the eastern part of the United States. Everyday life was both a challenge and struggle of self-sufficient existence as most early residents of the county had little or no time for anything but trying to survive. Their survival in this wilderness-like environment greatly depended upon their hands and their skills as they made just about everything they used in their daily lives, including the log cabins that were normally their first home. Likewise the early settlers grew, hunted, or fished for most of the food that they consumed, and they made most of their clothing. The hardy early settlers gradually prevailed over a period of time, thus transforming an untamed land into a viable and desirable place for the generations of Hertford County residents who came after them.

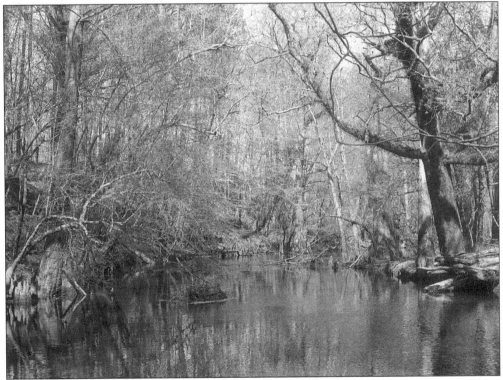

Early settlers to Hertford County found Potecasi Creek to be in a wild state and very little has changed, as it today remains virtually in the same rugged condition.

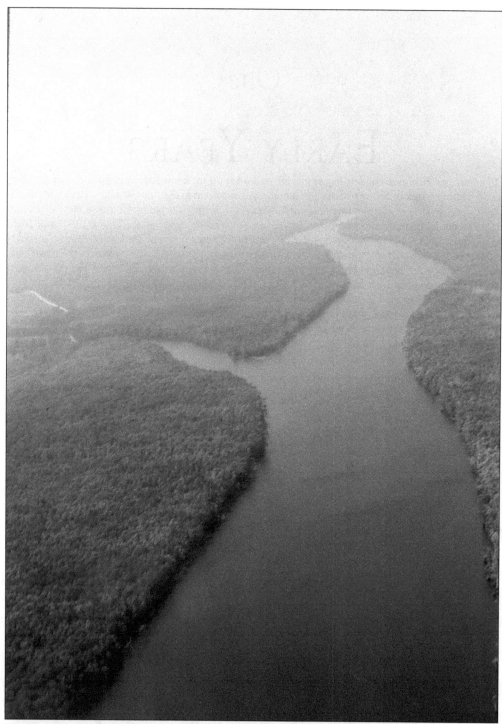

This is an aerial view of the Meherrin and Chowan Rivers looking north towards Virginia. The Chowan River forms the entire eastern boundary of Hertford County with the Meherrin River being the tributary going off to the left. Both rivers remain in a wild state similar to the condition that the first settlers to the county found when they first explored.

Here is a North Carolina Highway Historical marker near Winton commemorating the expeditions into the Hertford County region by explorers from the ill-fated colony on Roanoke Island, North Carolina.

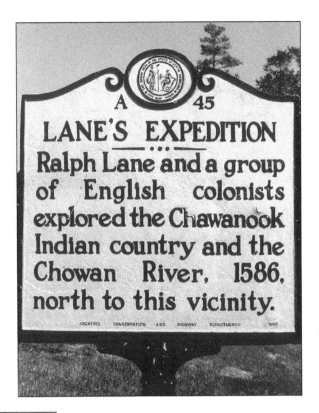

LANE'S EXPEDITION
— ••• —
Ralph Lane and a group of English colonists explored the Chawanook Indian country and the Chowan River, 1586, north to this vicinity.

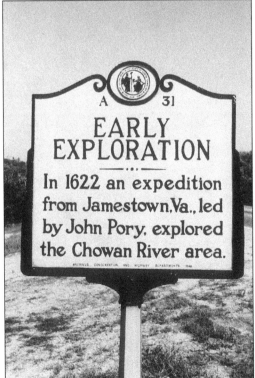

EARLY EXPLORATION
— ••• —
In 1622 an expedition from Jamestown,Va., led by John Pory, explored the Chowan River area.

Several expeditions into the Hertford County region were made by explorers from the Jamestown, Virginia settlement. This North Carolina Highway Historical marker notes the John Pory expedition of 1622.

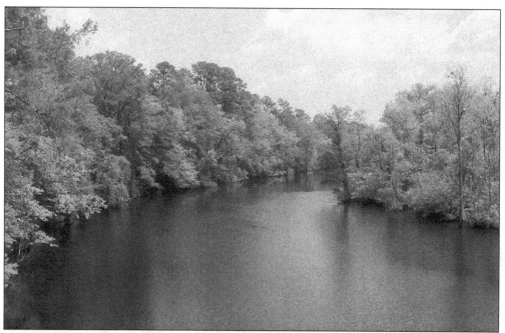

The Wiccacon River, located between Cofield and Harrellsville, rambles for about 17 miles in its wild state in the lower part of Hertford County. It is a tributary of the Chowan River.

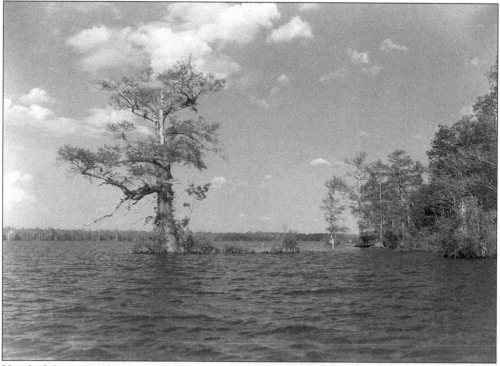

Hertford County's Chowan River shoreline presents a portrait of ruggedness and natural beauty just as it did 400 years ago when European explorers saw it for the first time.

Land transportation routes in the early years in Hertford County often were no more than a deeply rutted, single-lane dirt path as evidenced by this photograph of an abandoned 18th-century road that ran between Murfreesboro in Hertford County to Princeton in Northampton County.

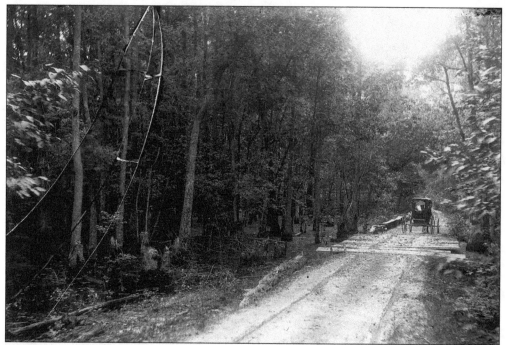

Hertford County in the 19th century began to see some improvements in its road system as evidenced by this early 1870s glass negative view of a stretch of road in the Como section. The road today is a part of U.S. Highway 258 north that runs between Murfreesboro and the Virginia state line.

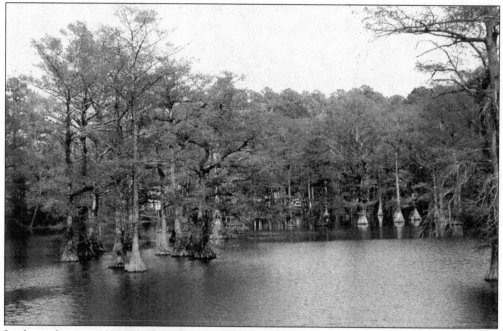

In the early years of Hertford County, a number of ponds associated with grist mills dotted the landscape. A few of these millponds—with their unsurpassed natural beauty—remain today, such as Hare's Millpond between Winton and Tunis.

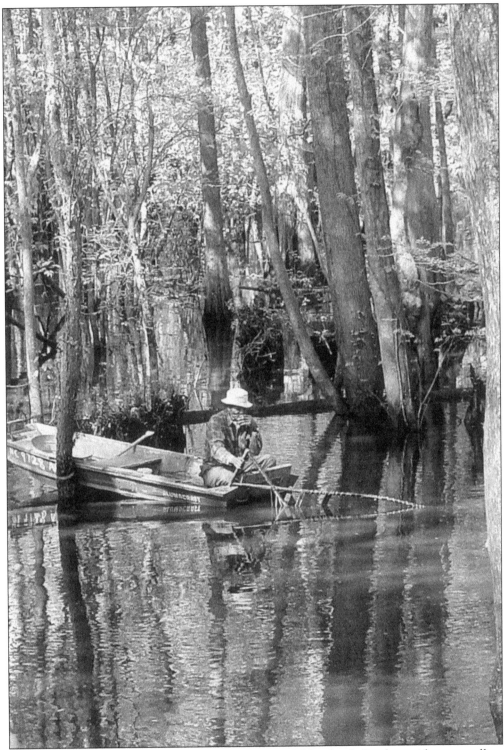

The raw and rugged natural beauty of Hertford County's Vaughan's Creek provides an excellent place for a herring fish bownetter to fill his boat.

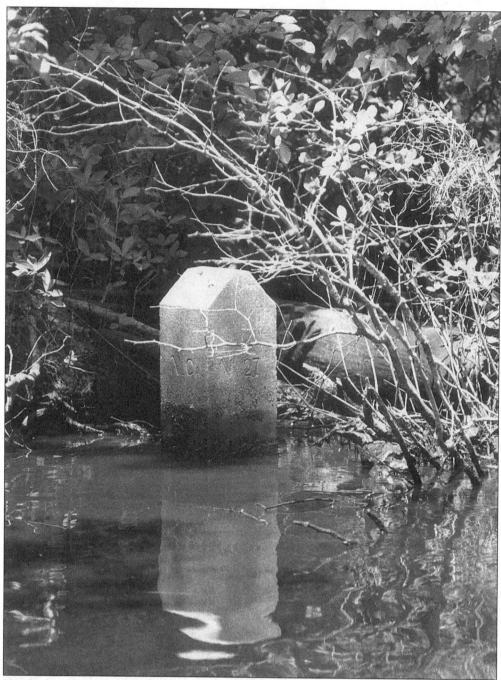

Hertford County's rugged landscape presented serious problems to the William Byrd 1728 Dividing Line Survey between Virginia and North Carolina. This was particularly true in the Hertford County border section where the Nottoway and Blackwater Rivers come together at the state line to form the Chowan River in North Carolina. In 1887 the original wooden state-line markers were replaced with stone markers, and this was no easy task due to the remaining rugged conditions. This marker is number 27 and stands at the very northeastern tip of Hertford County on the Virginia-North Carolina state line and is only accessible by boat.

Two

INTERESTING PEOPLE

There is no doubt that Hertford County has produced a wealth of sons and daughters who have brought fame and glory to themselves and their native county. Likewise Hertford County has also attracted people who have brought the same to their adopted county. This chapter is not a "Who's Who" list or an "Honor Roll," but it is about people from all walks of life and all races who called or still call Hertford County home and who did or are doing some interesting things with their lives. There is no way to ever forget the remarkable folk of this county such as Dr. Tom Browne, who is credited with founding in Ahoskie the 4-H Clubs of North Carolina; or Dr. Calvin Scott Brown, who founded Chowan Academy in Winton to educate black children; or James Henry Gatling, who built North Carolina's first airplane 30 years before the Wright Brothers flew at Kitty Hawk; or Howard Myrick, a Como horse whisperer who could talk to a mule or horse in such a way that the animal would not kick him while he was trimming its feet. We pause in this chapter to recall these and many more and to give thanks for their contributions to life in this place that we all know as Hertford County.

Murfreesboro's F. Roy Johnson wrote and published over 60 history books after retiring from newspaper publishing in 1963. He was literally a one-man publishing company as he researched, wrote, set the type, printed the books, bound them by hand, and sold them.

Walter G. Liverman is known as the "Hot Dog King" of Hertford County. Walter opened the Pastime Grill in Murfreesboro in 1940. In 1944 he built Walter's Grill in Murfreesboro and operated it until 1977. While Walter was most famous for his hot dogs, of which he made thousands and thousands, he also served up many other wonderful dishes. An Orange Crush served up with one or two of Walter's famous hot dogs garnished with mustard and Walter's special hot dog chili was always a big hit. Walter Goodman Liverman died in June 2001.

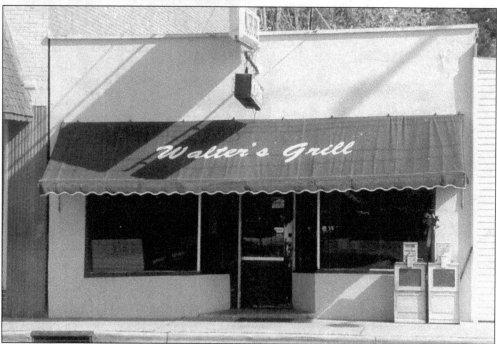

Walter's Grill in Murfreesboro has been a well-known eatery for nearly 60 years. It is located on Main Street in Murfreesboro in the original building that Walter G. Liverman built in 1944. Walter's Grill is now owned by Mr. and Mrs. Bill Theodorakis who have operated it since 1987.

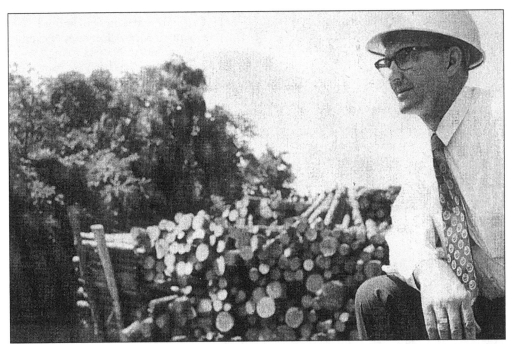

As his father before him, Harry B. Ward Jr. of Winton served as a tugboat captain on the Chowan and Blackwater Rivers for 44 years. Captain Ward operated several tugs for Union-Camp Corporation, pulling pulpwood from Hertford County and other locations in eastern North Carolina to the company's huge paper mill in Franklin, Virginia via the Chowan and Blackwater Rivers. Capt. Harry B. Ward Jr. retired from Union-Camp Corporation in 1981 as superintendent of marine operations.

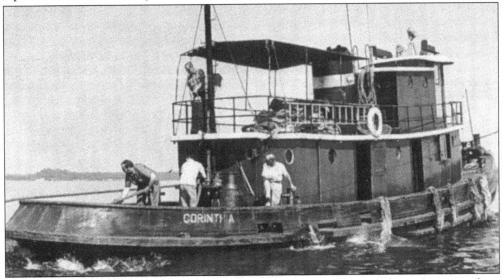

Capt. Harry B. Ward Jr. and his late father both operated the queen of Union-Camp's tugboat fleet, the *Corinthia*, for years on the Chowan River pulling pulpwood from Winton and other locations along the Chowan River. The *Corinthia*, built in Philadelphia in 1890, was purchased in 1937 by Camp Manufacturing Company, the predecessor to Union-Camp. The queen of the Chowan River faithfully served Union-Camp for 36 years until 1973 when it burned.

19

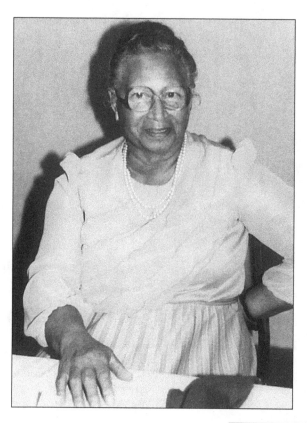

One of the treasures of Hertford County is Mrs. Alice Jones Nickens of Winton. At 99 years young Mrs. Nickens has been an inspiration and guiding light for all segments of the population. She was one of the first graduates of Chowan Academy, which later became C.S. Brown School. In 1922 Mrs. Nickens started teaching at Waters Normal Institute and taught there for a half-century through its name changes to Waters Training School and then to C.S. Brown High School. Even though Mrs. Nickens has been out of the classroom for some years, she has not stopped teaching and encouraging students to get as much education as they can.

Hertford County's most famous horse whisperer was Howard Myrick of the Como section. Mr. Myrick, who trimmed and shoed horse and mule feet, could walk up to a mule or horse and speak in a certain tone and manner in its ear and the animal would never kick him.

Hertford County native Dr. Richard Jordan Gatling was born in the Como section in 1818 and was the inventor of the Gatling gun in 1862. Dr. Gatling enjoyed a world reputation as an inventor holding over 60 patents for agriculture, firearms, and others for home and outdoor use. He died in February 1903 and is buried in Crown Hill Cemetery in Indianapolis, Indiana. Dr. Gatling had two ships named for him during World War II, a destroyer and a liberty ship.

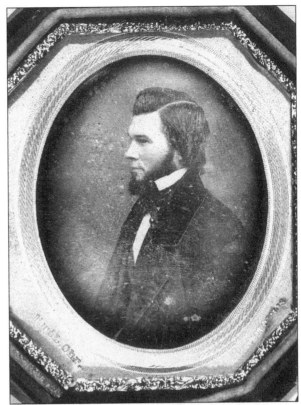

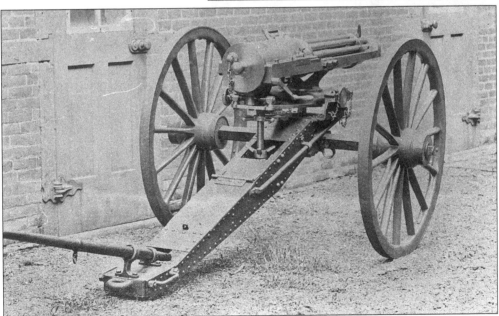

The Gatling gun was produced in many models and variations, including this early model. Although the Gatling gun was used very scantly during the Civil War it was used extensively around the world in the last part of the 19th century. Rapid-fire Gatling guns are utilized today by the armed forces of the United States.

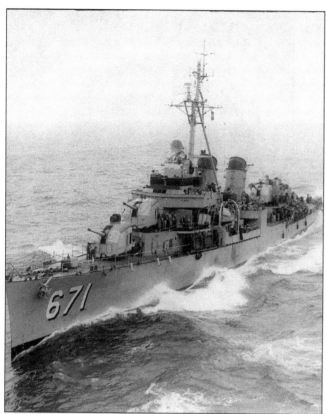

The destroyer *Gatling* was launched on June 20, 1943 at the Kearny, New Jersey shipyard. The ship was commissioned on August 14, 1943 and had a distinguished record in the Pacific during World War II and later during the Korean War. It was scrapped in the mid-1970s.

The liberty ship *Richard Jordan Gatling* was built and launched on October 14, 1942 at Permanete Shipyard, Richmond, California. None of the inventor's family was aware of the ship's construction at that time. The ship survived World War II and it is believed that it was sold to a foreign buyer in the early 1950s.

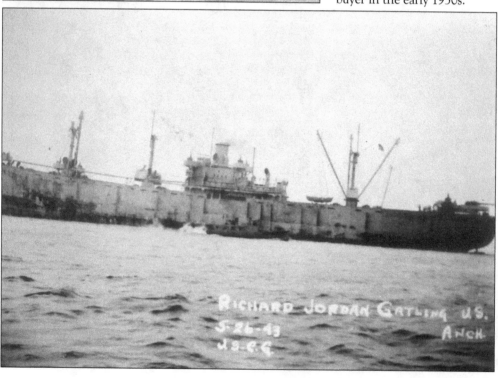

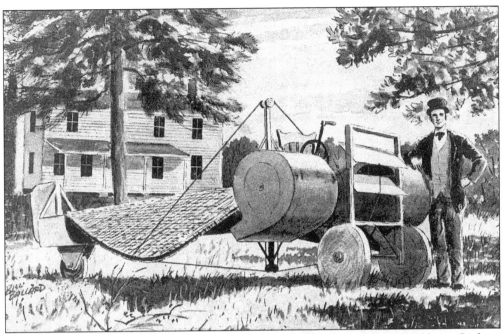

This is a sketch by Bill Ballard of Dr. Richard Jordan Gatling's brother, James Henry Gatling, who built a flying machine and attempted to fly it on the Gatling plantation in Como in 1873— some 30 years before the Wright Brothers flew at Kitty Hawk. Gatling's attempt to fly was the first in North Carolina. The Murfreesboro Historical Association has reproduced the Gatling flying machine and has it on display in one its museums in Murfreesboro.

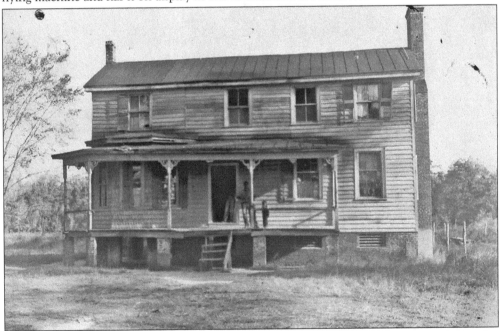

Richard and his brother James Henry Gatling were born in 1818 and 1816, respectively, in a log cabin that stood to the left of and behind this house that their father Jordan Gatling built on his plantation in 1824. This house stood until the 1970s.

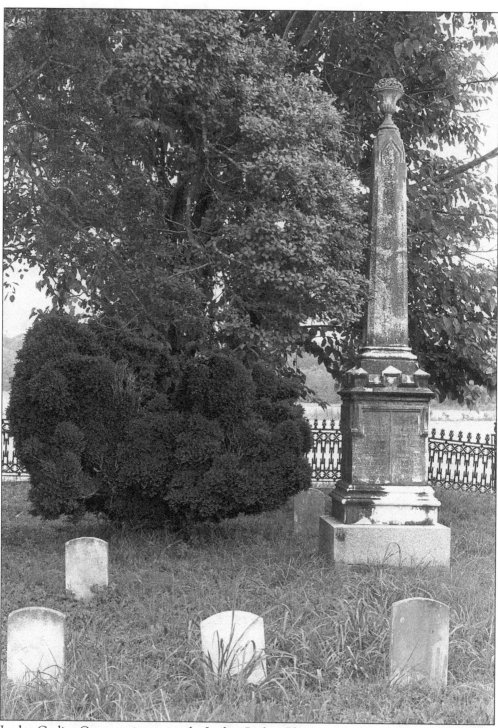

Jordan Gatling Cemetery is seen on the Jordan Gatling Plantation located in the Como section. Richard Jordan Gatling is not buried here but his parents, Jordan and Mary Barnes Gatling, are along with his brothers James Henry and Thomas and several sisters. James Henry Gatling had the big monument erected in the late 1860s.

Frank Stephenson Sr. of the Como section was a farmer and former Hertford County Deputy Sheriff for about 10 years. He also was a very good cook and became known as the Rockfish Muddle King of North Carolina. Fish muddle is made with rockfish or catfish along with tomatoes, country bacon, eggs, crackers, pepper, and onions. It is usually cooked in an iron washpot and is eaten with a spoon. It is not to be confused with fish stew.

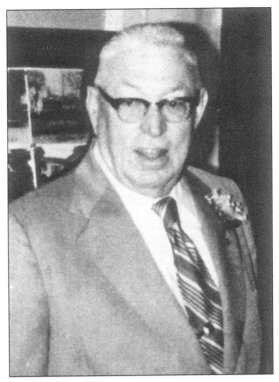

Atty. Carlton Cherry of Ahoskie made a national name for himself as the lawyer for Baseball Hall of Fame pitcher Jim "Catfish" Hunter. The national media and baseball club owners made their way to Mr. Cherry's office in Ahoskie when he was Jim Hunter's attorney. The club owners and the national media met their match in Mr. Cherry, who above anything else was a true country gentleman and highly respected.

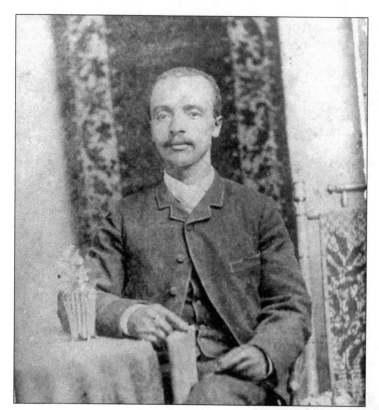

George Whitaker of the Como section was one of the inventors of the mechanical peanut harvester, commonly called the peanut picker, as pictured on page 92. The invention and development of the mechanical peanut picker revolutionized peanut farming in the South. This Whitaker family also was known for its snakebite cure.

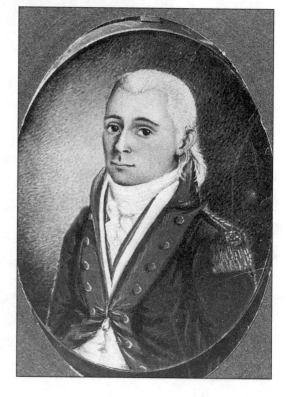

Col. Hardy Murfree was born in Murfreesboro on June 5, 1752. He served in the Revolutionary War in major battles including Brandywine and Monmouth. Hardy Murfree led a column of North Carolina troops in the capture of the British fort at Stony Point, New York on July 15, 1779. The town of Mufreesboro, North Carolina, was named in his honor as was the town of Murfreesboro, Tennessee. Murfreesboro, Arkansas, was founded in 1830 by descendants of Col. Hardy Murfree.

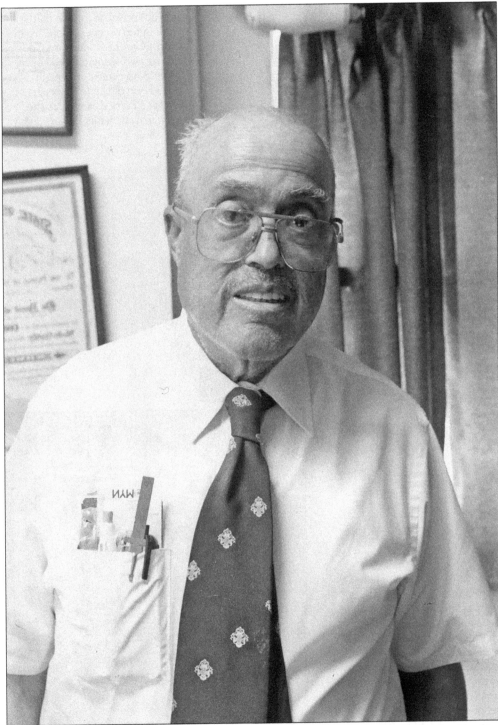

Dr. J.D. Weaver was one of the founders of the Ahoskie War Hawks baseball team in Ahoskie. He was a truly remarkable man who gave beyond measure to the Hertford County community.

It is unknown as to how many women ferrykeepers there are in North Carolina. Hertford County has its own woman ferrykeeper, Mary Ann Smith of Cofield. She is one of the ferrykeepers on Parker's Ferry that crosses the Meherrin River at Parker's Ferry.

In the days before people had running water in their homes, most of the water for home consumption came from wells that stood in the yard. These wells had to be dug and then kept cleaned out. One person who spent most of his life doing that was Alfred Ward of the Como section. Alfred Ward was born in 1874 and died in 1972; he is still fondly remembered for his loyal and dedicated service to his community as a well digger.

Miss Fostina Worthington was a Hertford County school teacher for 46 years. She taught at the Courthouse School, the Mapleton School, the Vaughantown Rosenwald School, schools in Virginia, and the Mill Neck Rosenwald School in the Como section for 32 years. She was a graduate of Waters Training School and Elizabeth City State. Miss Tina, as she was fondly called, was a devout member of Mill Neck Baptist Church.

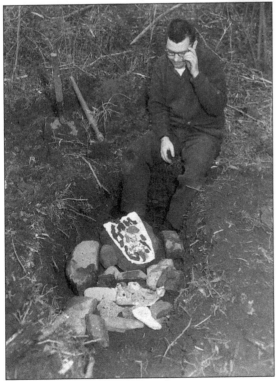

Winton native Dr. Thomas C. Parramore has brought honor to himself and his home county for his outstanding historical research on the Roanoke-Chowan and other locations. He is the author of numerous books and articles on North Carolina and Virginia history and taught history at Meredith College prior to his retirement in 1992. Dr. Parramore continues his outstanding research on Hertford County and other regions.

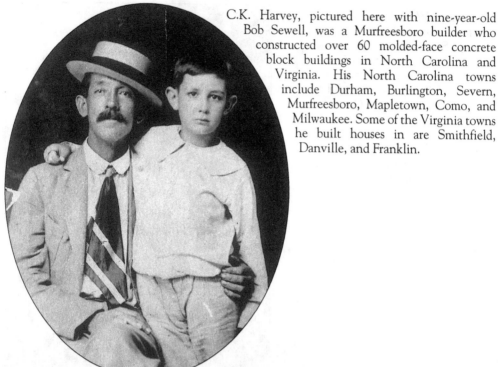

C.K. Harvey, pictured here with nine-year-old Bob Sewell, was a Murfreesboro builder who constructed over 60 molded-face concrete block buildings in North Carolina and Virginia. His North Carolina towns include Durham, Burlington, Severn, Murfreesboro, Mapletown, Como, and Milwaukee. Some of the Virginia towns he built houses in are Smithfield, Danville, and Franklin.

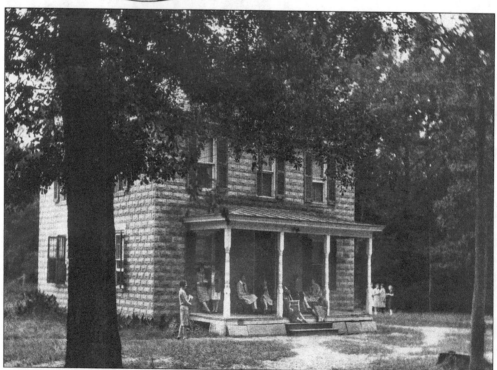

In 1913–1914 C.K. Harvey built Stone Hall on the campus of Chowan College for use as a dormitory. In later years the building housed the college's music department.

Dr. Calvin Scott Brown came to Hertford County from Salisbury, North Carolina to preach at Pleasant Plains Baptist Church near Winton following his graduation from Shaw University. The legacy that Dr. Brown left is almost beyond measure. C.S. Brown School in Winton bears his name but the most profound impact he had on this entire region was in the education of an untold number of African-American children through Chowan Academy, Waters Normal Institute, and later C.S. Brown School in Winton.

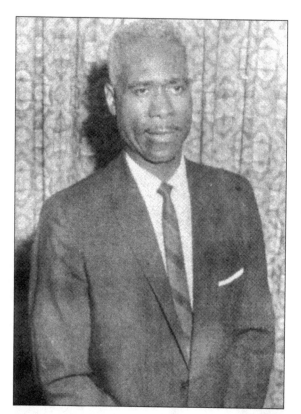

There is a section of North Carolina Highway 11 south of Murfreesboro that bears the name "Rev. James A. Felton." Reverend Felton was a teacher and principal at Mill Neck Rosenwald School in Como and from there he had a long and distinguished career in education, the ministry, and community activism.

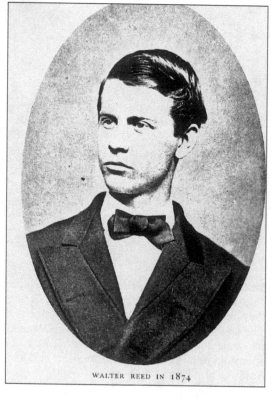

WALTER REED IN 1874

Dr. Walter Reed lived in Murfreesboro on two different occasions while his father was pastor at the Murfreesboro Methodist Church. He married Emily Lawrence of Murfreesboro. Walter Reed Army Hospital in Washington, D.C. was named in his honor for his outstanding achievements in medicine.

Rev. William Reid was the founder of Mill Neck Baptist Church in the Como section. He was Mill Neck's pastor for over 50 years and helped organize other churches in the West Roanoke Association. Rev. William Reid was a great preacher, a dedicated leader, and a highly respected gentleman.

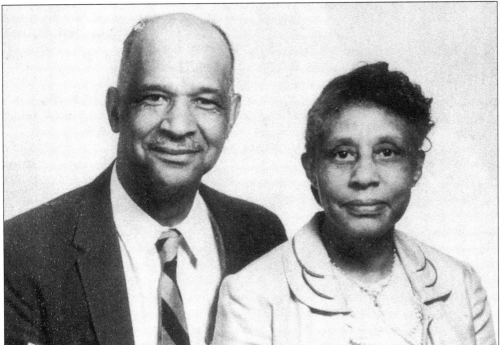

Dr. and Mrs. Wendell C. Somerville were members of the Mill Neck Baptist Church in Como for many years where they had a home. Mrs. Somerville (Alice E. Cooper) was a native of the Como section and was a school teacher in Hertford and Wake Counties. Dr. Somerville was elected general secretary of the General Baptist State Convention of North Carolina in 1935 and in 1940 he became executive director of the Lott Carey Convention, where he had a long and distinguished service. The Somervilles together traveled the world extensively in the interest of foreign missions.

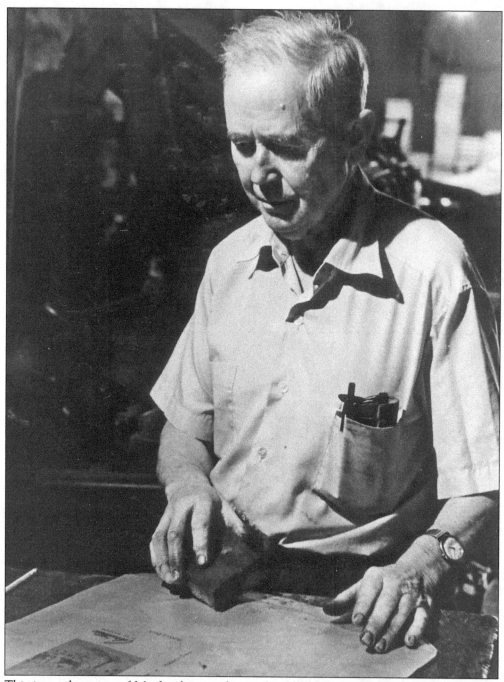

This is another view of Murfreesboro author and publisher F. Roy Johnson. He was a truly remarkable man whose passion was folklore and history of the region. He earned a national name for his books on Nat Turner, native Americans, peanuts, and folklore. Roy Johnson died in 1988.

Dr. James Spurgeon Jordan was the founder and owner of the Como Eagles baseball team in Como. He was born in in 1871 and died in 1962, having lived his entire life in and around Jordan's Corner in the Como section. Jordan's Corner became well-known on the East Coast of the United States because of Dr. Jordan's thriving medical practice.

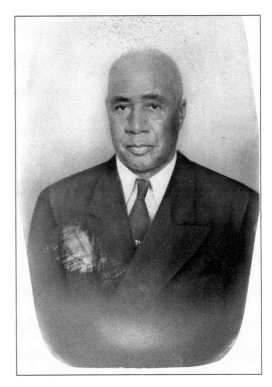

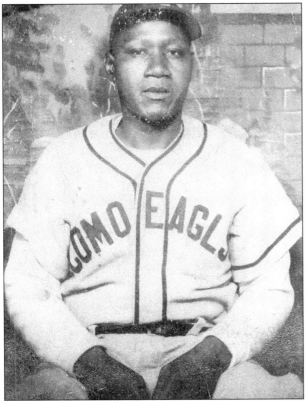

David Collin "Ran" Jordan was a pitcher and the general manager of his father's baseball team, the Como Eagles. The Como Eagles had a record over a span of 12 years in the 1940s and early 1950s of 242 wins, 18 losses, and 2 ties.

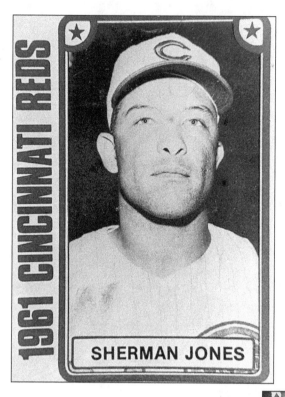

1961 CINCINNATI REDS

SHERMAN JONES

Winton native Sherman "Juke" Jones enjoyed a major league baseball career that spanned 12 seasons with the New York Giants, the Cincinnati Reds, and the New York Mets. He had been an outstanding pitcher with the Chowan Bees in Winton.

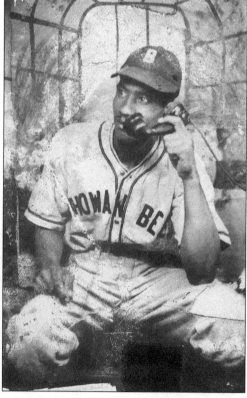

Elbert Archer of Winton was an outstanding third baseman for the Chowan Bees, a semi-pro baseball team based in Winton. The Chowan Bees, the Ahoskie War Hawks, and the Como Eagles were African-American semi-pro teams based in Hertford County and all three were nearly unbeatable. These three teams rarely ever lost a game and that included the games they played against teams from the Negro major leagues. The Chowan Bees record for a span of 10 years during the 1940s and early 1950s was 245 wins, 8 losses, and 1 tie.

36

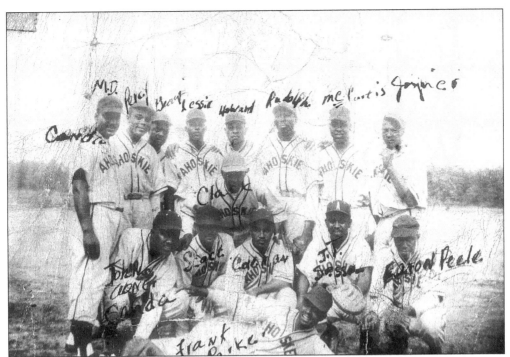

The Ahoskie War Hawks of 1948 had a record of 25 wins and 1 loss. The team record for a period of 10 years in the 1940s and 1950s was 235 wins, 21 losses, and 2 ties.

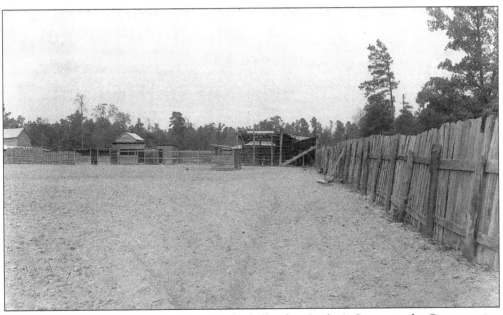

This is a 1955 photograph of the Como Eagles ballpark at Jordan's Corner in the Como section of Hertford County. Ran Jordan and his log woods crew laid out and built the park c. 1947. Many great teams played and lost here including the Homestead Grays, the Indianapolis Clowns, the New York Cubans, the New York Black Yankees, the New York Blue Jays, and many more. The Como Eagles never lost a game in this park to teams from the Negro Major Leagues.

Indianapolis Will Play Tilt With War Hawks

Winton. — The Indianapolis Clowns of the Negro American League continue their current campaign this Saturday afternoon when they will make their first visit of the season to Winton to cross bats with the Ahoskie War Hawks ball club in a exhibition baseball contest scheduled to get underway at 2:30 p. m.

With their brilliant ball-playing and inimitable showmanship, the Clowns long have been the outstanding attraction and drawing card of Negro baseball. Their pregame show headed by the "Clown Prince" King Tut and his able staff of assistants is what the fans really turn out to see in such large

This newspaper account of Ahoskie War Hawks appeared in the April 27, 1950 issue of *The Herald*, Ahoskie, North Carolina. The Ahoskie War Hawks defeated the Indianapolis Clowns in that game by a score of 6 to 1.

Three

Education and Culture

The history of the education of Hertford County's children, both black and white, follows in many respects the same familiar path as other counties in the South. During slavery the education of any child, regardless of race, was dismal at best. The exception to this, of course, was the children of plantation owners or wealthy businessmen who could afford to hire tutors and teachers. Hertford County did have a number of academies for the education of white males scattered about. Included were Union Academy in Harrellsville, Hertford Academy in Murfreesboro, and Buckhorn Academy in Como. There were several academies for white females including Elm Grove Female School in Mapleton and several schools for girls in Murfreesboro. In the field of higher education the county had two colleges for women open in Murfreesboro—Chowan College in 1848 and Wesleyan College in 1853. While Wesleyan College is no longer operating following two fires, the last being in 1893, Chowan College has been in operation since 1848 except for the period 1943–1948 because of World War II. In 1969 the closed North Carolina prison unit at Union became Roanoke-Chowan Community College .The establishment of Chowan Academy in Winton in 1886 by Dr. Calvin Scott Brown significantly improved the educational opportunities for black children in the county and subsequently the region. But the educational opportunities for many of the black children in Hertford County was still in question, thus prompting the construction of 10 Rosenwald Schools in the county during the period 1918–1929.

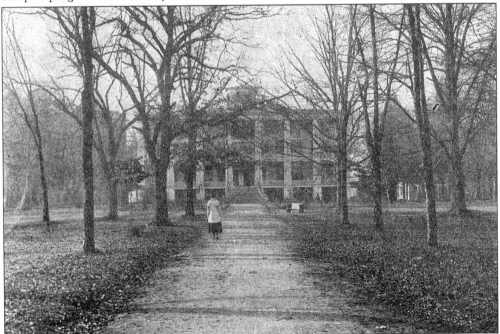

The Chowan College campus is seen on a cold winter day in the early 1920s.

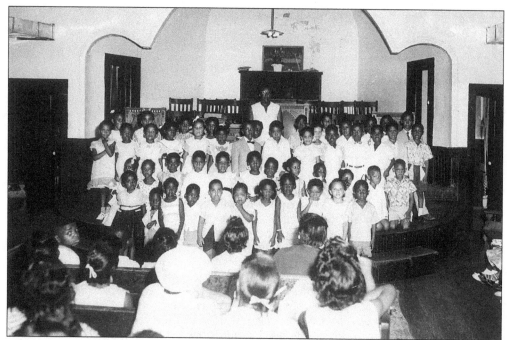

This is an undated photograph of Mrs. Luvenia Rouson's kindergarten class in Murfreesboro. The photograph was taken in the sanctuary of the Murfreesboro First Baptist Church, which stood on East Broad Street.

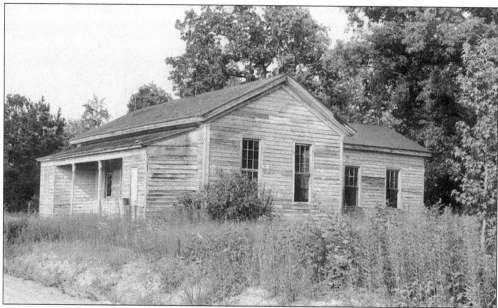

Courthouse School was one of a number of schools scattered around Hertford County for the education of African-American children; it stood on the Hill's Ferry Road in the Jordan Town section of Como. The building originally was built for Buckhorn Academy and stood on the grounds of Buckhorn Baptist Church. When Buckhorn Academy closed around 1900 the building was moved to the Hill's Ferry site and utilized as a school for black children for approximately 50 years.

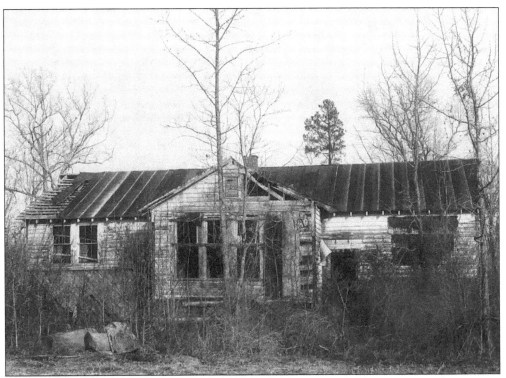

This building is what remains of the Cotton Rosenwald School today. The Cotton Rosenwald School was built in 1923 and 1924 and served as a school for about 40 years.

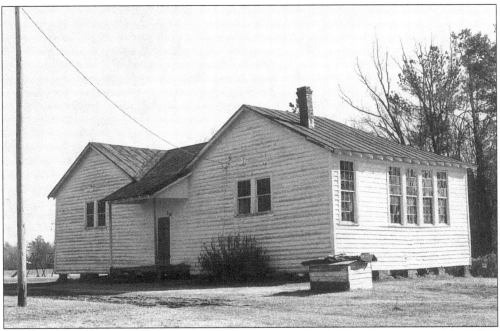

The Vaughantown Rosenwald School is located in the Vaughantown community, about four miles south of Murfreesboro. The building was constructed in 1918 and 1919 and served students from that area until it was merged with Riverview School in Murfreesboro

Mt. Sinai Rosenwald School stood on the Boone's Bridge near Mt. Sinai Baptist Church in the Como section of county. The school was built in 1925 and 1926 and served students for about 35 years. It burned in the1970s while in use as a private residence.

Millneck Rosenwald School still stands today across the road from Millneck Baptist Church in the Millneck section of Como. The school was constructed in 1926 and 1927 and was active as a school for about 35 years.

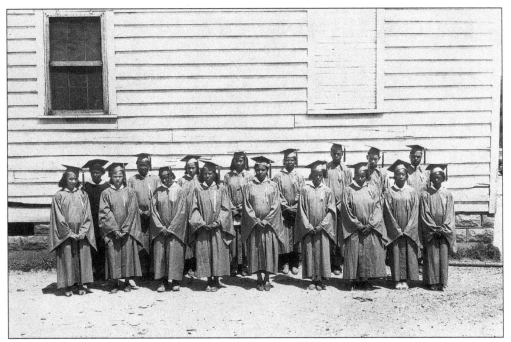

Rev. George Rouson taught school in Murfreesboro for many years after moving there in 1924. Joel Holland, a Murfreesboro photographer, took this photograph of Rev. Rouson's eighth-grade graduation on May 26, 1944 at a school in Murfreesboro.

Ahoskie High School became one of the great secondary schools in North Carolina. Its academic programs and athletic teams were outstanding and on par with many of the larger schools in the South.

BUCKHORN ACADEMY,
HERTFORD COUNTY, N. CAROLINA.
JULIAN PICOT, A. M., PRINCIPAL.

THE finest located and prosperous Schoo now open for the reception of pupils.

The Scholastic year is divided into two equal sessions; the first commencing the 1st Monday in September, and the 2d the 1st Monday in February.

The rates of Tuition are as follows :

Primary Department per session of 5 months, $9,00
Highest Branches of English, 12,00
The Languages, including French, with
 the higher mathematics, 15,00

A deduction will be made for those who may enter at an advanced stage of the session. The Library of the Principal, which is large and well selected, will be open for the use of the students.

Board may be obtained in the vicinity for $9,00 per month. Sep 21-1y

This ad for Buckhorn Academy appeared in the September 18, 1871 issue of the *Baltimore Inquirer*. The academy, which was located on the grounds of Buckhorn Baptist Church in Como, was founded in 1820 by Samuel Nicholson.

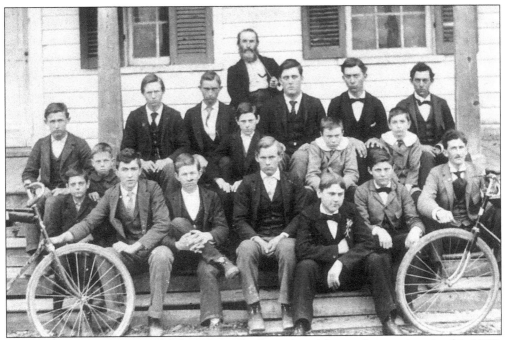

Buckhorn Academy principal Julian Picot (back row) and his students appear in this 1880s photograph. Julian Picot was principal of Buckhorn Academy for about 50 years. The academy stood on the grounds of Buckhorn Baptist Church in Como and was one of the South's great schools for boys. Included in its graduates were lawyers, physicians, educators, and state and federal politicians.

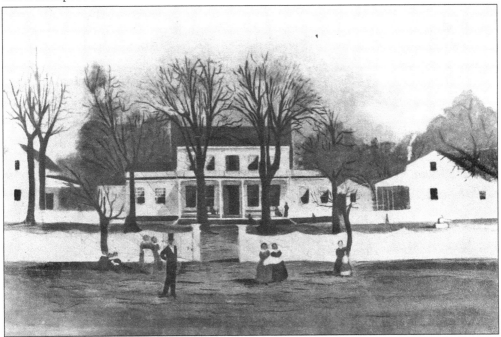

The village of Mapleton was home to Alfred Darden's School for girls. This painting of school was made in the 1870s.

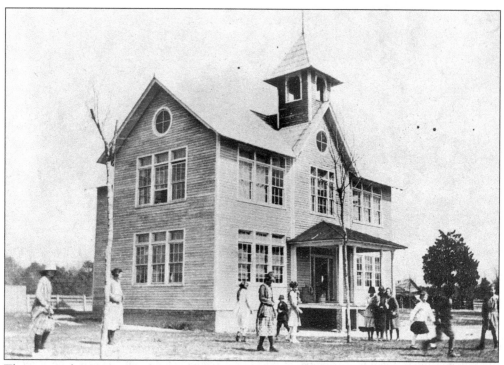

This is an early 1920s view of Como High School. In the early 1940s, the school was consolidated with Murfreesboro High School.

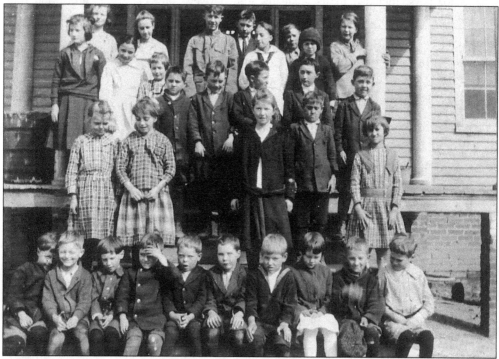

In 1915, the students at Como High School posed for this picture. The school operated into the early 1940s and later was used as the Como community building.

46

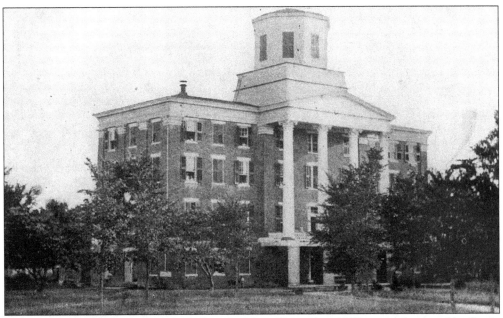

Here is the first Wesleyan Female College building. Erected in 1853, it was destroyed by fire in 1877. The college was located in the Wynn-High Street section of Murfreesboro, not far from the campus of Chowan College.

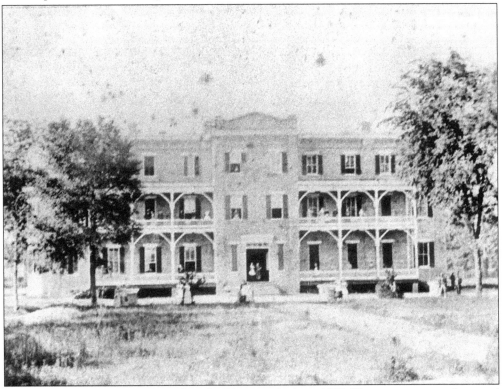

The second Wesleyan Female College building was built in 1881. This structure was destroyed by fire in 1893. The college did not reopen following the second fire.

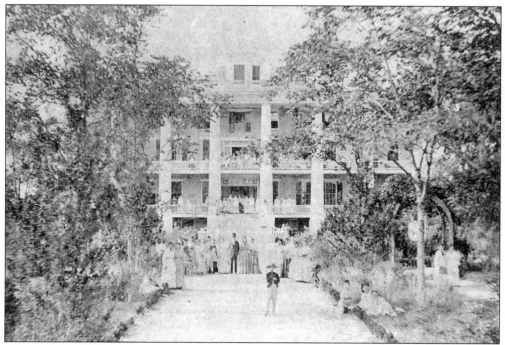

This 1870s view of Chowan College is one of the earliest-known photographs of the college.

This 1870s view of the front lawn at Chowan College gives insight into the formal landscape plan that was implemented when the main campus was developed in the 1850s.

A 1920s view of the main drive around the front lawn at Chowan College is seen here. This same drive today has dormitories lining the right side and a small number of the original pines have survived.

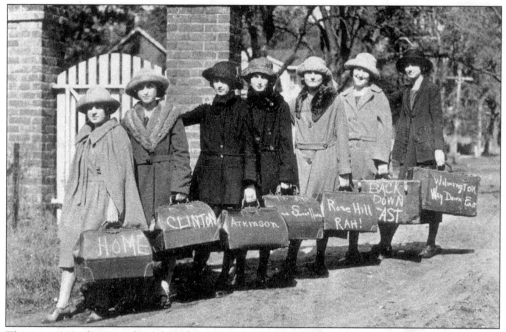

This is a 1923 photograph of the Chowan College Down East Club.

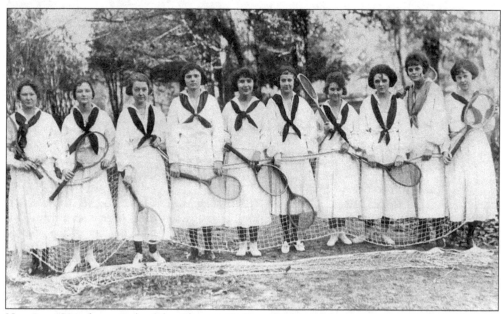

Here is a 1921 photograph of the Chowan College Tennis Club.

This is a photograph of the 1941 Chowan College May Day Queen and her court.

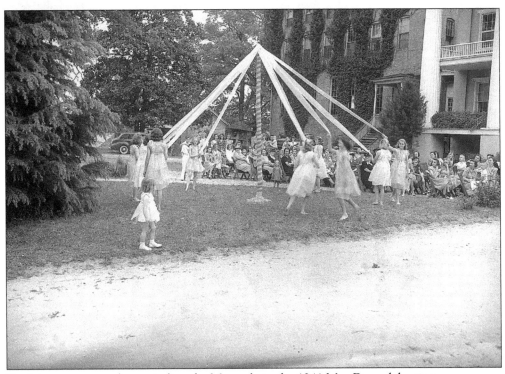

Participants are seen here winding the May pole in the 1941 May Day celebration.

Members of the 1941 Chowan College May Day court on the front walk.

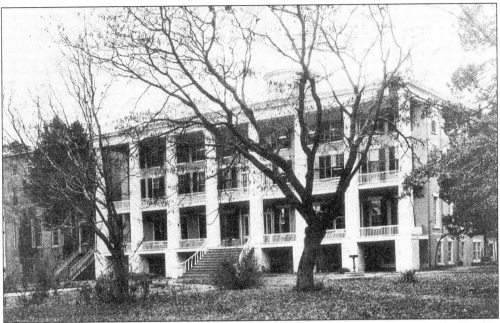

Here is a 1922 view of the main building at Chowan College. The building was constructed in 1851 by A.G. Jones. It remains in use today as the college's administration building.

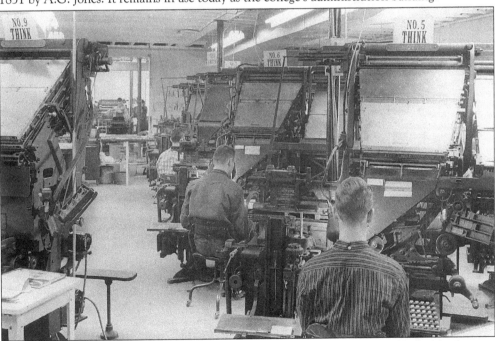

In 1949 Roy Parker, owner and publisher of *The Hertford County Herald* in Ahoskie was instrumental in establishing The Roy Parker School of Printing at Chowan College. The chief reason behind Mr. Parker's efforts was to provide North Carolina and the nation with trained linotype operators as seen in this early 1960s photograph. Today the Chowan College School of Graphic Communications is a world-class educational facility teaching young men and women the latest in printing technology.

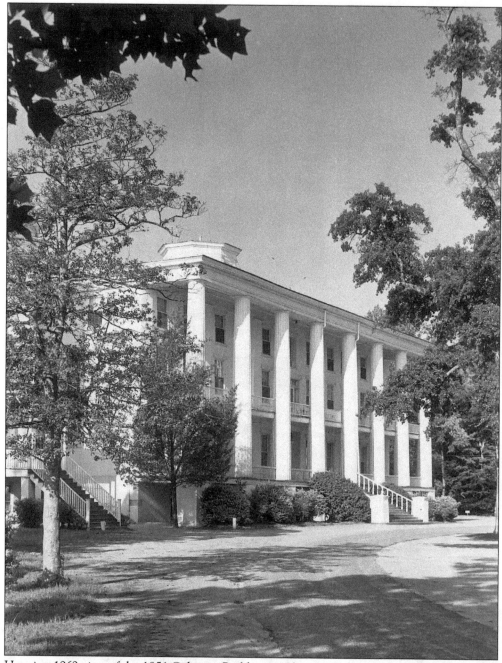

Here is a 1969 view of the 1851 Columns Building at Chowan College.

Four

MEHERRIN INDIANS

The fact that the Meherrins have survived today as a tribe is a tribute to their determination, faith, and fortitude to be fully recognized as Native Americans. While there is much of their early history that we do not know, we do know that they are of the same linguistic stock as the Cherokee, Tuscarora, and other tribes of the Iroquois nation of New York and Canada. Their beginning appears to have been in Virginia, in and around the Emporia area and particularly near the Meherrin River. This region was home to the Meherrins for untold number of years—perhaps as far back as 600 years before the colonial era. The written history of the Meherrins, who were never a large tribe, numbering around 700, began on August 29, 1650, when Edward Bland, an English businessman, five other Englishmen, and two Native Americans from other Virginia tribes visited them near Emporia. In just a few years pressure from English settlers and periodic attacks from other tribes forced the Meherrins to leave the Emporia region and settle in Hertford County at the site known today as Parker's Ferry. The Parker's Ferry site was actually claimed by both North Carolina and Virginia, which had established a reservation for the Meherrins there. The issue of where the state line was between the two colonies/states was settled in 1728 with the Meherrin reservation ending up in North Carolina. In just a few short years the Meherrins had lost most of their lands, their numbers had dramatically decreased, and what few remained took refuge up nearby Potecasi Creek in an area of Hertford County known as the California section. In October 2003 the Meherrins, now numbering around 900, will hold their 15th Annual Pow-Wow on their tribal grounds, four miles south of Murfreesboro.

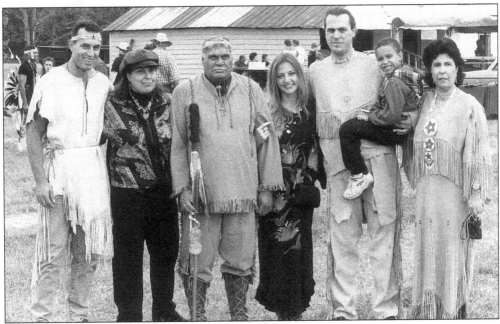

Pictured here is Meherrin Indian Chief Calvin Hall and his family of Winton.

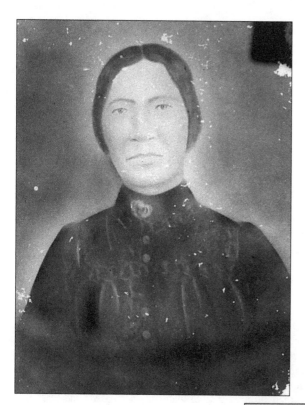

Sallie Lewis was born in 1838 to Meherrin Indian parents. She is fondly remembered today as one of the matriarchs of the Meherrin native American tribe. She died in 1904.

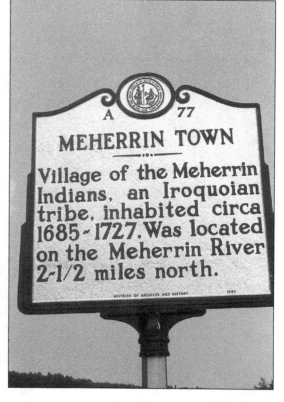

In 1995 the North Carolina Historical Commission erected this highway marker commemorating the Meherrin Indian town site at Parker's Ferry. The Parker Ferry's site has been home to Native-American tribes for centuries.

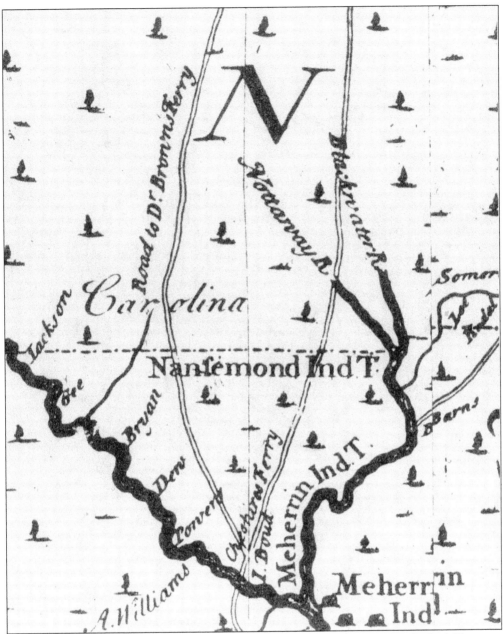

The Mosley Map of 1733 shows the location of the Meherrin Indian town at Parker's Ferry.

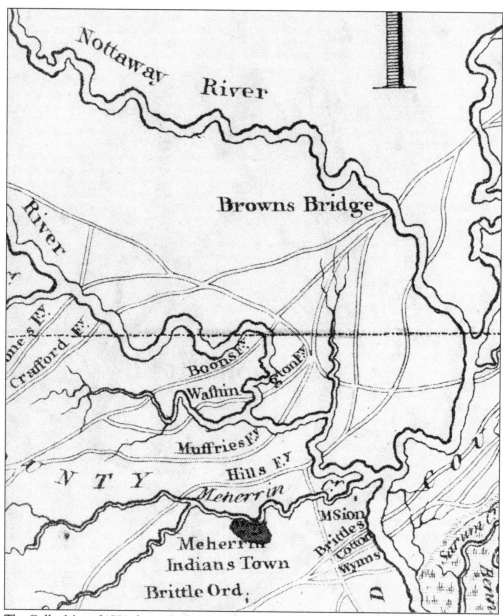

The Collet Map of 1770 shows the last-known Meherrin Indian town site. The site was located on the Potecasi Creek, very close to Beechwood Country Club.

This is a Meherrin Indian clay vessel found at the Meherrin Indian town site at Parker's Ferry. It is currently on display at Murfreesboro Museum.

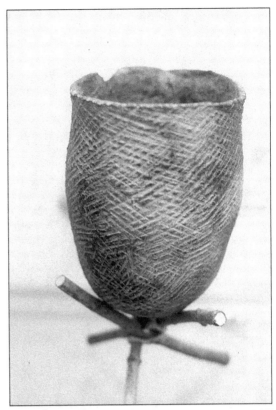

This group photograph of the Meherrin Indians was taken at their 2001 Pow-Wow at their tribal grounds, located on North Carolina Highway 11, four miles south of Murfreesboro.

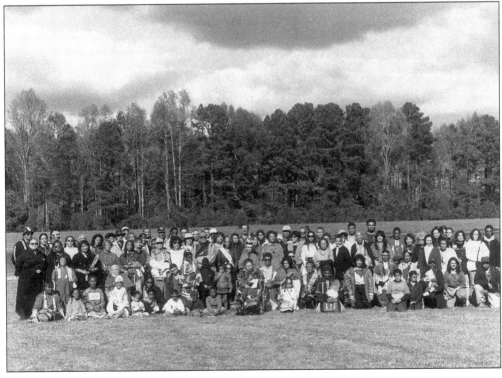

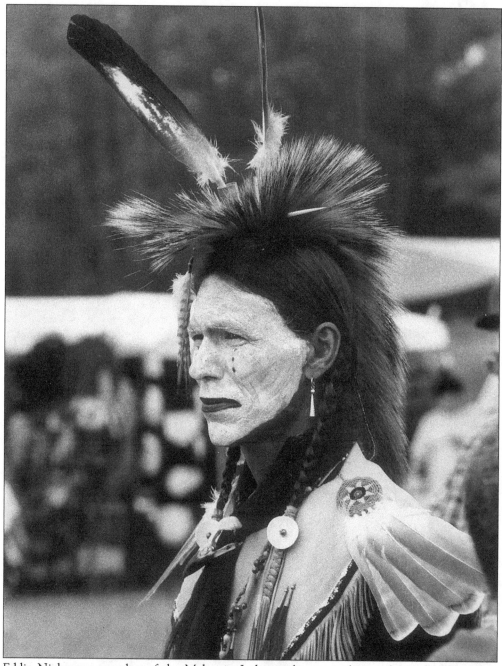

Eddie Nickens, a member of the Meherrin Indian tribe, wore this at the Meherrin Indian Pow-Wow of 1997.

This sign is located on the Meherrin tribal grounds.

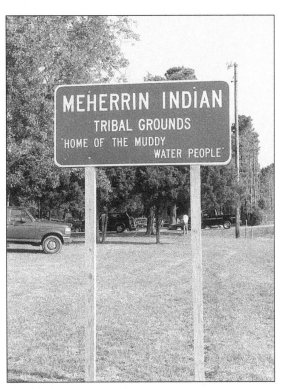

This beautiful stream today is known as Liveman's Creek. Originally called Indian Creek, it one time served as the western boundary of one of the Meherrin Indian reservations in the Como section.

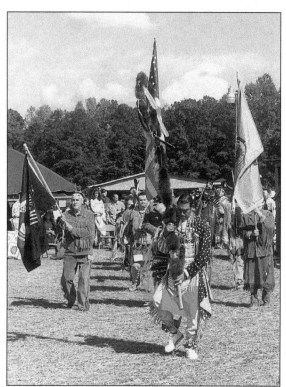

Shown here is the grand entry at the 2001 Meherrin Indian Pow-Wow.

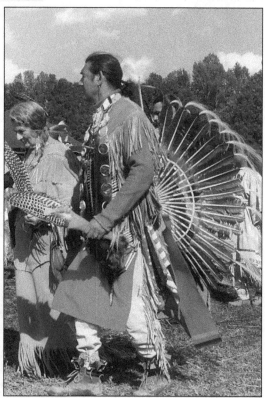

Meherrin Indian council member Thomas Two Feathers Lewis is seen here at the 2001 Meherrin Indian Pow-Wow.

Pictured here are Meherrin tribal members at the 2001 Meherrin Indian Pow-Wow.

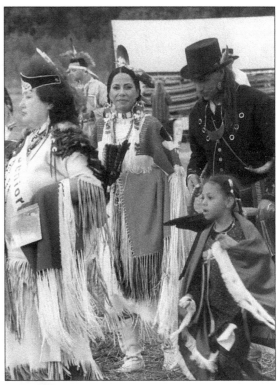

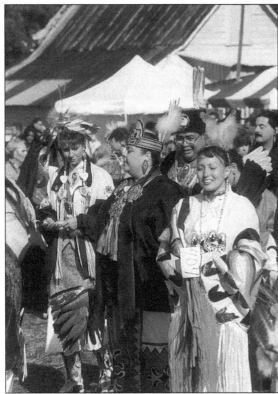

Here are more Meherrin tribal members at the 2001 Meherrin Indian Pow-Wow.

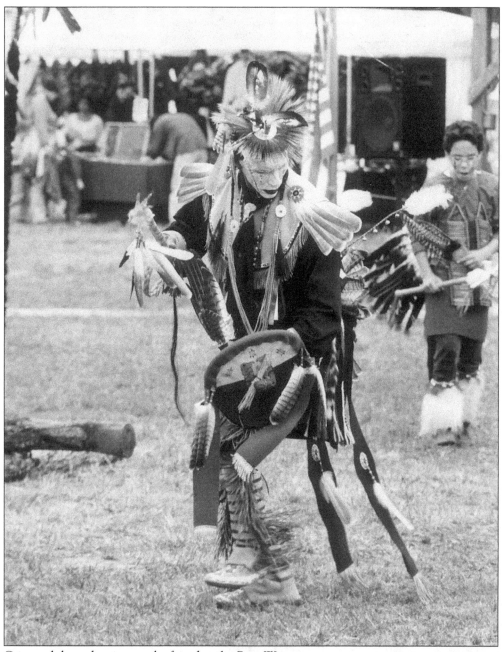

Crisp and sharp dancing can be found at the Pow-Wows.

Five

CHOWAN BEACH

AFRICAN-AMERICAN RESORT

In 1928 Winton businessman Eli Reid purchased an old but very beautiful site on the Chowan River known as Chowan Beach. He had leased the site for two years prior to purchasing it from the Jordan family of Winton. The site, also known as Mt. Gallant, had been utilized for years as a herring seine fishery and in the 1700s a ferry crossed the Chowan River from there to Gates County. Eli Reid had a vision of transforming it into a first-class African-American resort and playground. He achieved his goal and Chowan Beach became one of the premier African-American resorts on the East Coast, attracting people far and wide by bus loads. Vacation cottages, a wide sandy beach, and a merry-go-round and other midway-type equipment—along with excellent food and warm hospitality—were the signature hallmarks of this remarkable place. Chowan Beach not only became a favorite for local and regional African Americans, but it attracted such black professionals as college professors, business executives, medical and dental doctors, and governmental officials who vacationed there with their families. Chowan Beach also served as a 4-H camp for African-American children from North Carolina. One of the most interesting aspects about Chowan Beach involves the number and caliber of black entertainers who played there. These include B.B. King, James Brown, Ruth Brown, Clyde McPhatter, Joe Turner, Little Willie John, Mable John, Sam Cooke, Earl Grant, and many more.

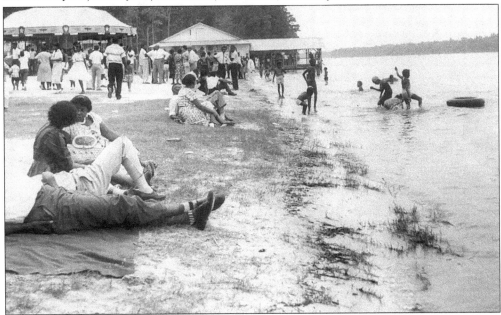

Chowan Beach became one of the premier African-American resorts on the east coast of the United States. It attracted large crowds, as evidenced by this July 4, 1957 photograph.

65

Here is one of the many ads that Eli Reid ran to promote Chowan Beach. This ad is from the August 17, 1939 issue of *The Hertford County Herald*, of Ahoskie. Mr. Reid ran ads in numerous newspapers including *The Norfolk Journal and Guide* and other African-American publications.

Many visitors to Chowan Beach took photographs of themselves at the beach's photography studio. The man in this photograph is Eli Reid, owner and operator of Chowan Beach.

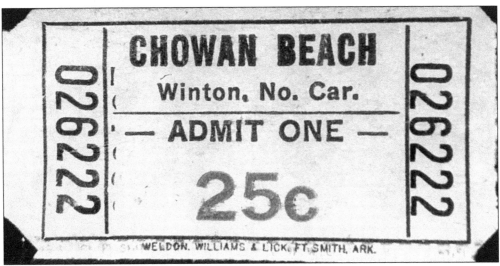

This is a Chowan Beach general admission ticket from 1955.

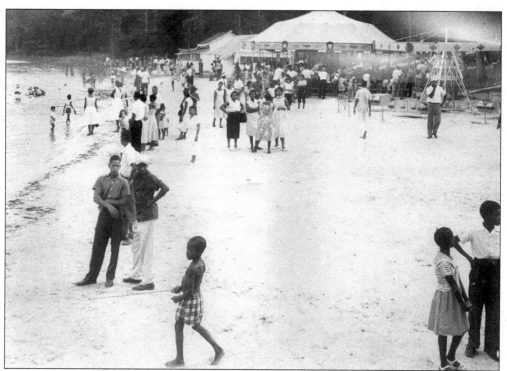

Here is a Chowan Beach scene from July 4, 1957.

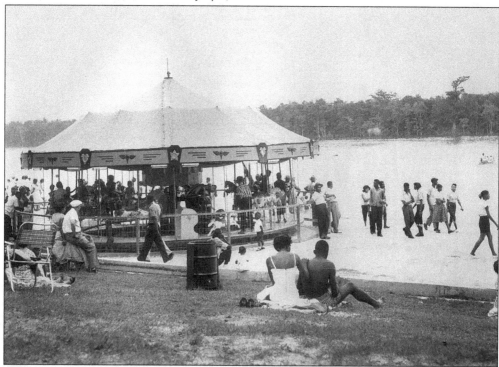

The carrousel at Chowan Beach was always a big hit with visitors as seen in this July 4, 1957 photograph.

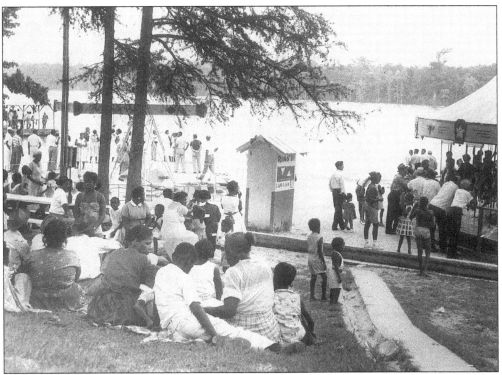

Two more views depict families enjoying Chowan Beach on the Fourth of July in 1957.

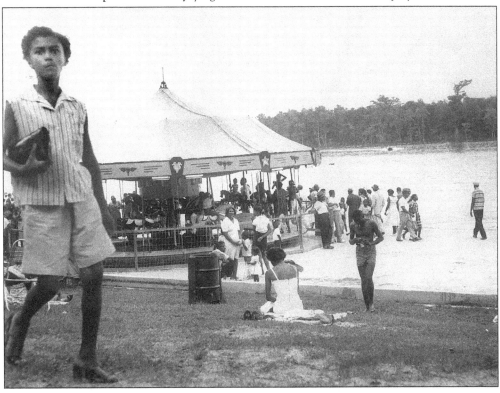

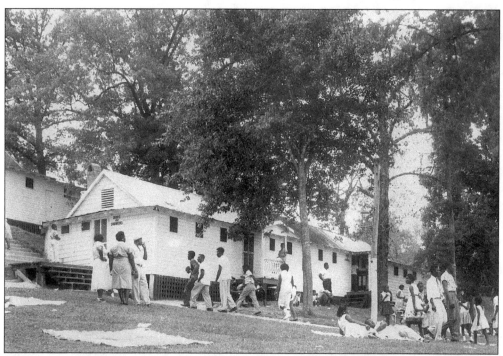

Another July 4, 1957 photograph shows the restaurant that was located at Chowan Beach. It was known for excellent food and outstanding service.

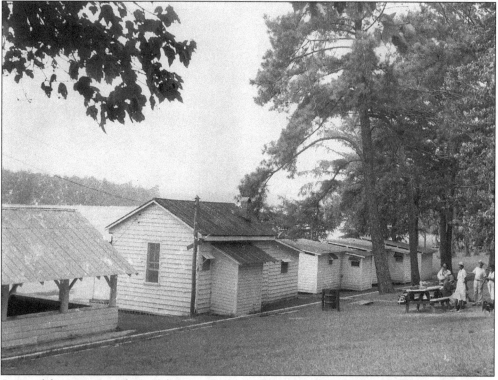

Some of the vacation cabins and picnic facilities at Chowan Beach are seen on July 4, 1957.

Clyde McPhatter was one of a large number of Rhythm and Blues stars who performed early in their careers at Chowan Beach. B.B. King played at Chowan Beach a number of times.

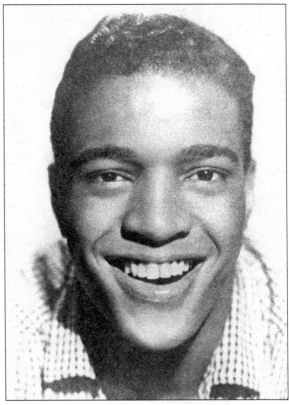

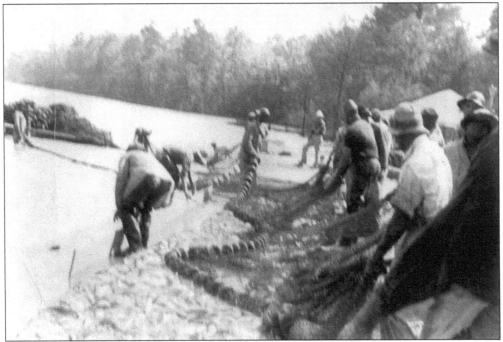

One of the largest herring haul seines on the upper Chowan River was located at Chowan Beach, as seen in this 1941 photograph.

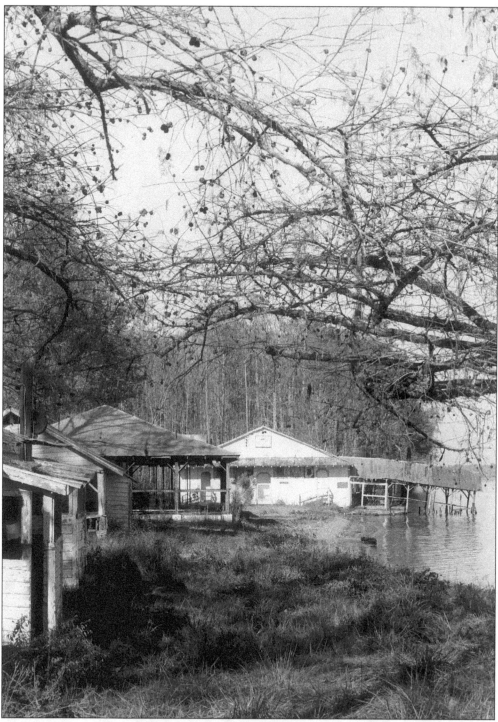

Time and tide wait for no man, and this is certainly the case with Chowan Beach today as seen in this 1997 photograph. The echo of great and wonderful times past can still be heard at this magnificent site.

Six

HERRING FISHING
A WAY OF LIFE AND CULTURE

Each year in March, April, and May when there is a full moon over Carolina, when the dogwoods are in full bloom, and when the Easter season is approaching, the alewife or river herring migrate from the Atlantic Ocean by the millions to the Meherrin and Chowan Rivers to spawn. For centuries, persons living in Hertford County, whether Native Americans, colonists, or current residents, have used various devices, from reed baskets to bow nets to pound nets to river seines, to catch these silvery salt water fish. A way of life, culture, and industry centered around herring fishing developed in Hertford County and prospered for many years with scores of herring fisheries lining the banks of the Meherrin, Chowan, and Wiccacon Rivers and such creeks as Potecasi, Swain's Mill, Buckhorn, Catherine, and Chinkapin. Due to pollution and overzealous trawling by foreign fishing fleets off the North Carolina coast, the annual catch of river herring has dropped dramatically and the once-booming industry is nearly gone. Today, the herring fishermen who operate Williams Seine Fishery, Parker's Ferry Fishery, Hollowell's Fishery, and Tunis Fishery, all in Hertford County, are practicing an ancient art that will all but disappear in a few years, taking with it a unique way of life and culture.

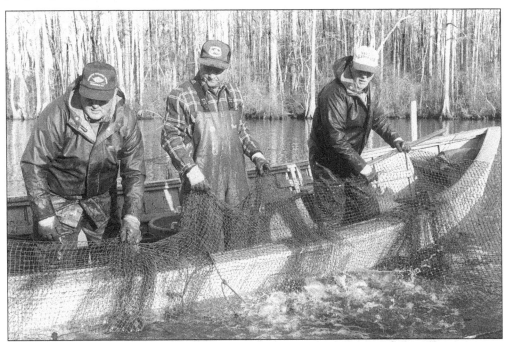

Men from Tunis Fishery are seen with one of their herring pound-nets on the Chowan River.

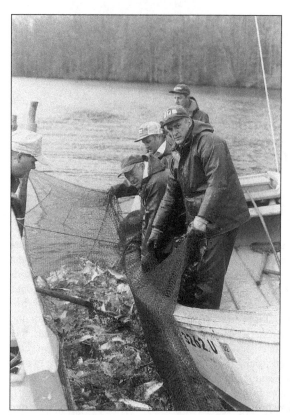

More fishermen from Tunis Fishery are pictured on the Chowan River. Pound-net fishing is hard, ugly, and dangerous work and it takes rugged men and women to endure it.

The Tunis Fishery, located on the Chowan River, was founded in the 1930s by Peter B. Griffith, a longtime Chowan River herring fisherman. Today Tunis Fishery, one of the few herring fisheries remaining on the Chowan River, is owned and operated by Mr. and Mrs. Tony Stephenson.

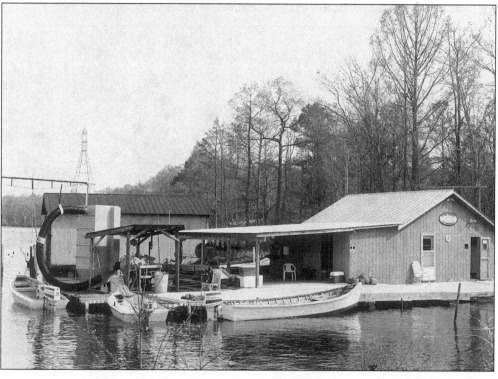

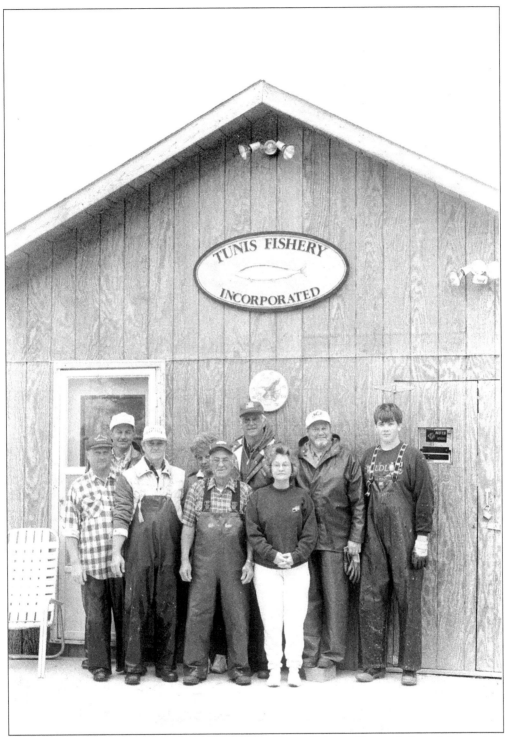

This is the herring pound net fishing crew at Tunis Fishery. Pictured from left to right are Troy Godwdin, Lynn Harrell, Bobby Bryant, Shirley Stephenson, C. M. Hoggard, Tony Stephenson, Brenda Romines, Olin Romines, and Justin Grizzard.

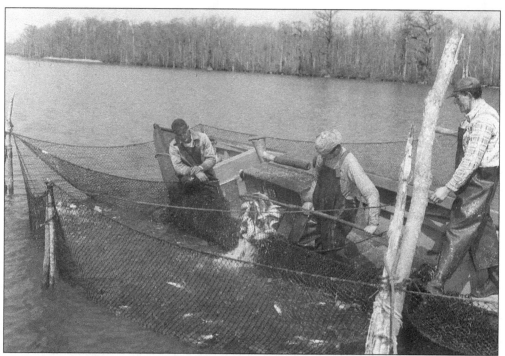

From left to right, Leroy Eure, Brantley Jefferies and Jobe Williams are fishing herring pound nets on the Chowan River in the 1950s.

This is a late 1940s photograph of Swain's Mill, a herring fishing village located off the Chowan River near Harrellsville.

Williams Seine Fishery is located about a mile below Murfreesboro on the Meherrin River. There has been a herring haul seine at this site for over 100 years.

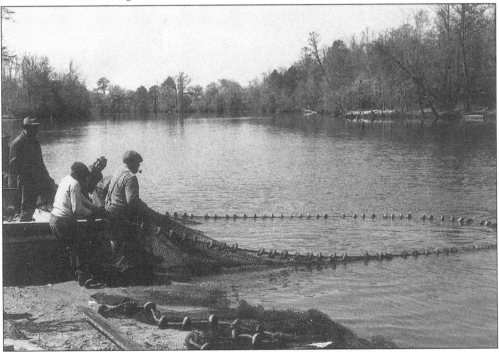

This is a 1960s photograph of Eugene Reid's herring seine fishery on the Meherrin River just above Murfreesboro. During the 18th and 19th centuries millions of salted herring were shipped out of Murfreesboro by boat.

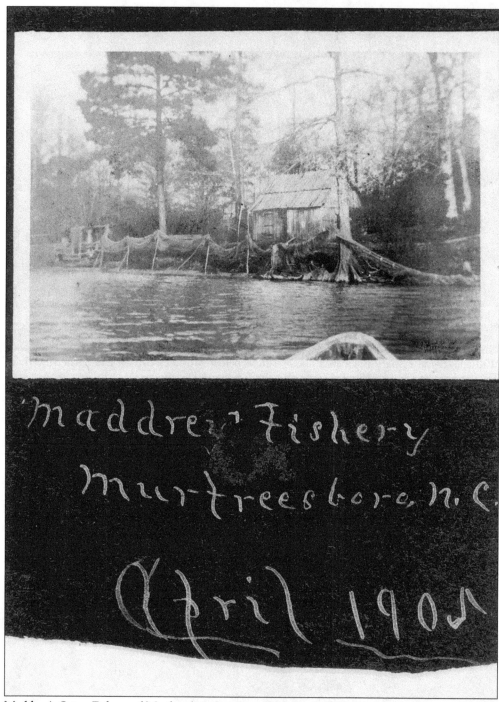

Maddrey's Seine Fishery of Murfreesboro is pictured in April 1905. Maddrey's was just one of a large number of herring fisheries that lined the Meherrin and Chowan Rivers through the years.

Haul seiners are loading the seine for another pull or haul across the Meherrin River at Williams Seine Fishery, about a mile below Murfreesboro. According to the North Carolina Marine Fisheries Division, Williams Seine Fishery is the last commercial haul seine remaining in North Carolina.

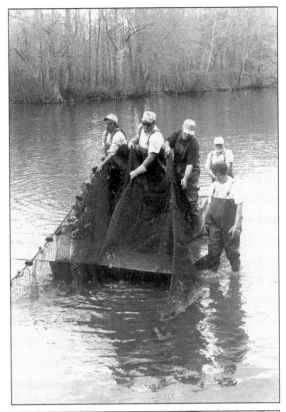

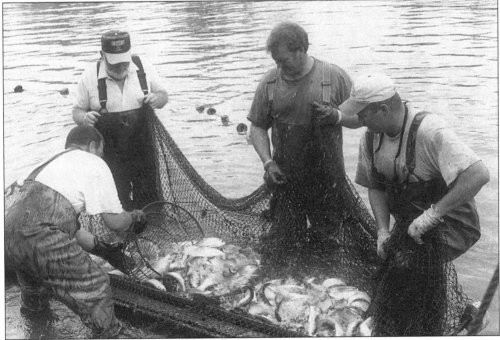

Haul seiners are unloading the seine net following another successful haul or pull of the seine across the Meherrin River at Williams Seine Fishery.

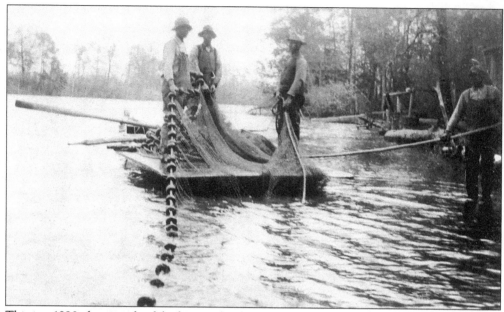

This is a 1920 photograph of the herring haul seine being loaded at Paul Jordan's seine fishery, which was located about four miles south of Murfreesboro on the Meherrin River.

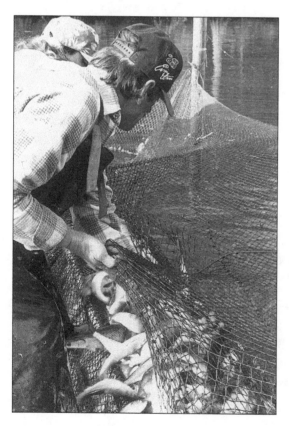

Dennis and Loretta Layton, owners of Parker's Ferry Fishery on the Meherrin River about five miles below Murfreesboro, are fishing one of their herring pound nets.

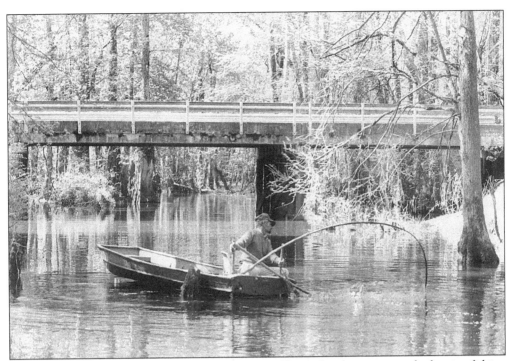

A herring bow net fisherman sets his bow net in Vaughan's Creek, a very popular herring fishing site just north of Murfreesboro. Vaughan's Creek bridge is in the background.

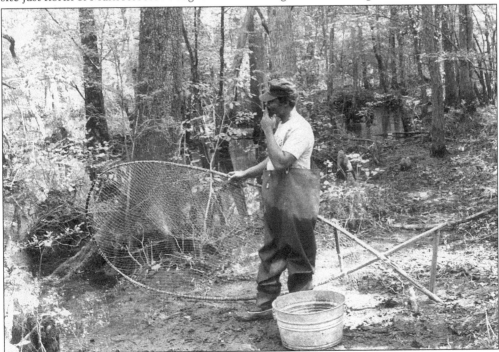

Herring bow net fisherman is seen taking a break on the banks of Vaughan's Creek north of Murfreesboro. Vaughan's Creek attracts herring fishermen from miles around during the herring fishing season.

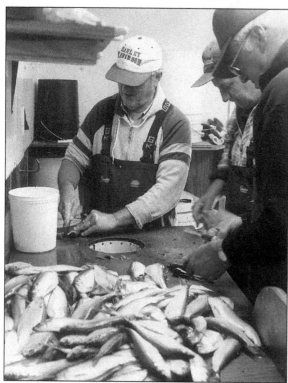

The pound net crew at Tunis Fishery is cleaning herring caught earlier in one of their pound nets on the Meherrin River.

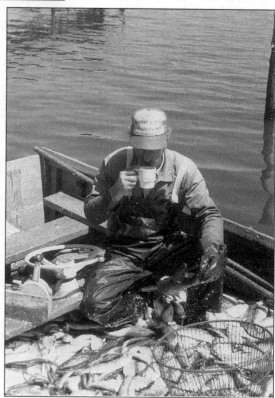

Walter Jeffries of Tunis Fishery is seen taking a coffee break in the 1970s.

A Tunis Fishery herring pound net crew is seen unloading herring from one of their pound nets on the Chowan River.

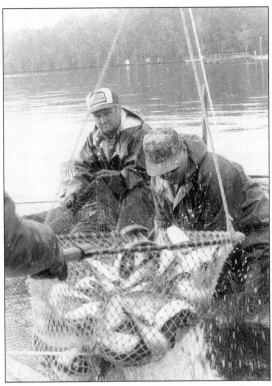

Ernest Brett, a herring bow net fisherman, is checking out the scene at Vaughan's Creek, a favorite herring fishing location north of Murfreesboro.

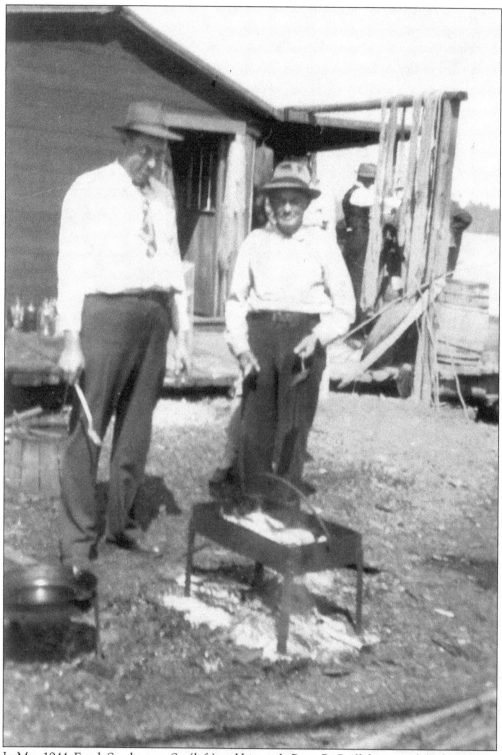

In May 1944, Frank Stephenson Sr. (left) and his uncle Peter P. Griffith are cooking herring on the riverbank at his uncle's herring fishery at Tunis.

Seven

FARM LIFE

PEANUTS, TOBACCO, CHITLINS, AND GRITS

Hertford County depended heavily upon agriculture to provide a living for its citizens. Such field crops as peanuts and tobacco have been the backbone of its economy for years. Much of the county's soil, particularly the Norfolk sandy loam, was found to be particularly suited for growing peanuts, especially the larger cocktail variety. Planter's Peanuts and other peanut processors acquired thousands of tons of peanuts grown in Hertford County for use in a variety of products. Tobacco, just like peanuts, has been grown in Hertford County for several centuries. But it was not until some years following the Civil War that flue-cured tobacco became prominent in the county and in other tobacco producing locales. What followed, including the famous Bull Durham smokes, was the development of a cigarette-making machine by a Virginia man named James A. Bonsack. Bonsack installed his machine in the Duke tobacco factory in Durham and the rest is history. An explosion of tobacco followed in North Carolina, including Hertford County, and a very prosperous tobacco market developed in Ahoskie. The production of top-quality tobacco on Hertford County farms has played a major role in the development of the county and in the welfare, education, and quality of life of its people. Unfortunately the once-prosperous Ahoskie tobacco market closed two years ago, and a way of life and culture died with it.

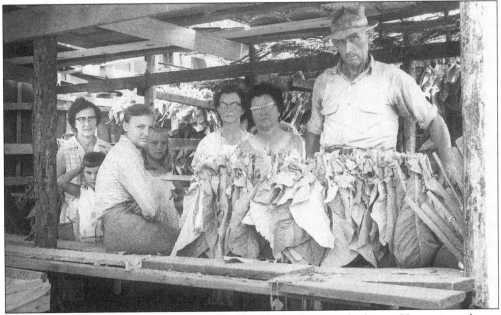

A Hertford County tobacco farmer holds a stick of freshly harvested tobacco. Harvesting tobacco was labor intensive and often involved the entire family and friends and neighbors.

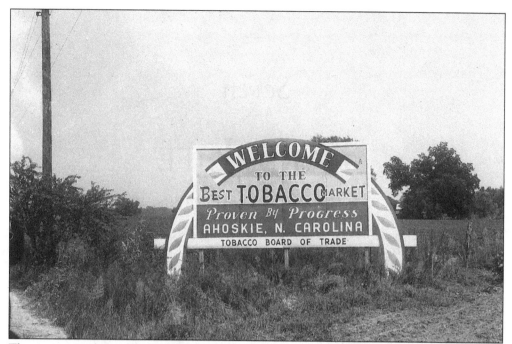

This sign greeted travelers entering Ahoskie from the northern approach on U.S. Highway 13. The sign is believed to have been erected in the late 1940s.

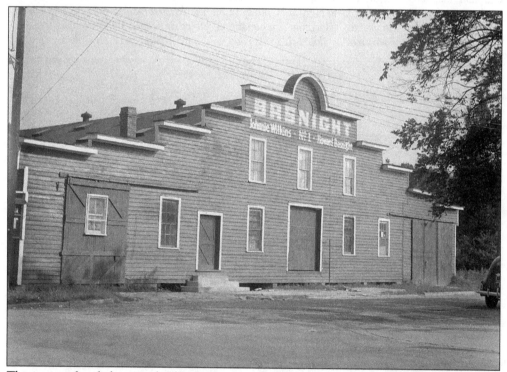

This is an undated photograph of Basnight tobacco warehouse number one, which was operated by Johnnie Wilkins and Howard Basnight. The photograph dates from the early 1940s.

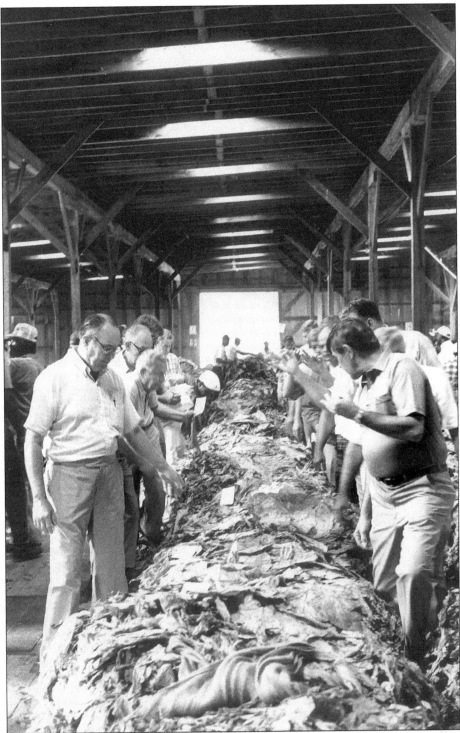

Shirley Pierce and Burhead Odom, two longtime tobacco warehousemen with Farmers Tobacco Warehouse Company in Ahoskie, are seen leading a tobacco auction and sale in September 1992.

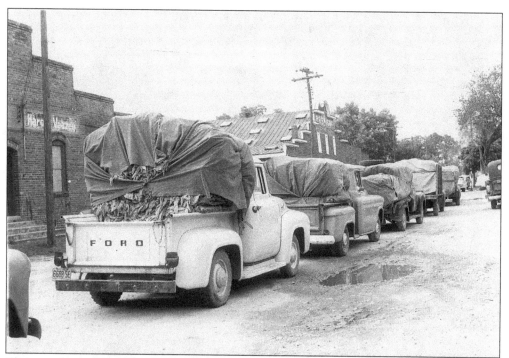

These trucks are ladened with freshly cured tobacco and waiting in line to be unloaded at the Ahoskie tobacco market. The tobacco would be auctioned or sold at the next sale.

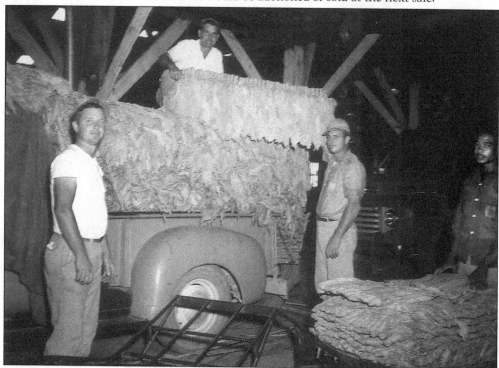

This mid-1950s photograph shows a tobacco farmer unloading cured tobacco inside one of the tobacco warehouses at the Ahoskie tobacco market.

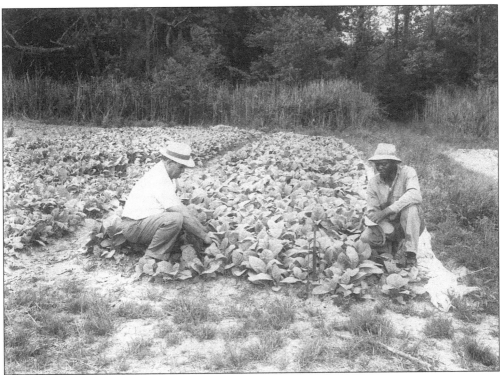

Tobacco beds were prepared in the winter months with tobacco seeds to produce young tobacco plants for transplanting in the spring months. This 1950s photograph shows two tobacco beds.

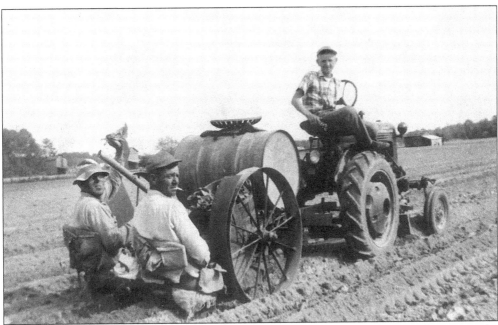

Fred Nichols (sitting on the tractor), his father Ross Nichols, and another man (sitting on the tobacco transplanter) are seen transplanting tobacco in the 1950s.

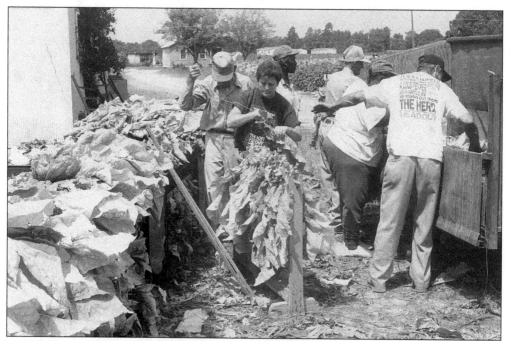

In 1996 Barbara Nichols Mulder and members of the Fred Nichols tobacco harvesting crew took one last look back at the old method of looping tobacco.

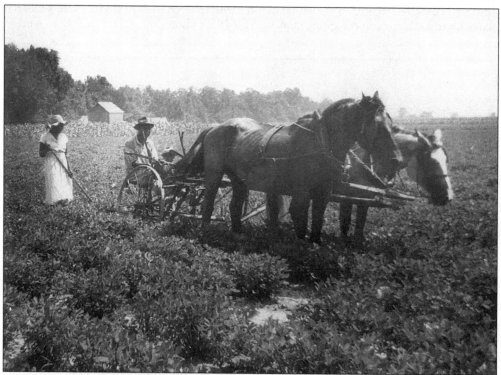

Before farm tractors became available, peanuts and other farm crops in Hertford County were cultivated with a team of mules and horses.

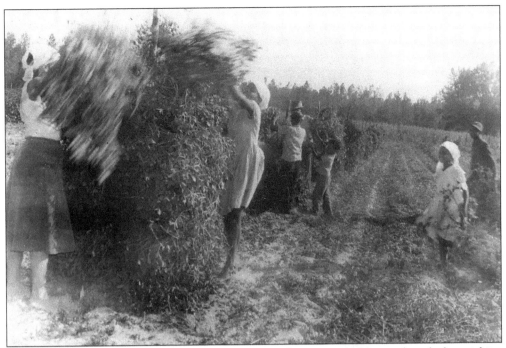

For years and years green peanuts were stacked by hand as a means of drying them before picking them off the peanut vines. This photograph was taken on the Frank Stephenson Sr. farm in the Como section in the mid-1950s.

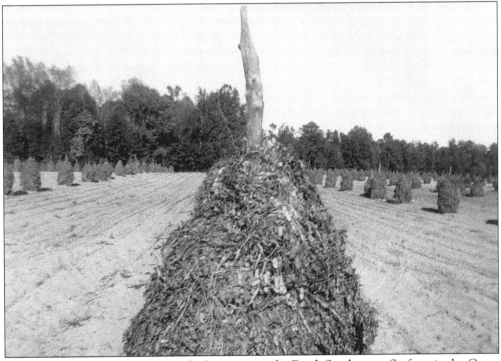

This is a 1957 view of a field of stacked peanuts on the Frank Stephenson Sr. farm in the Como section of the county.

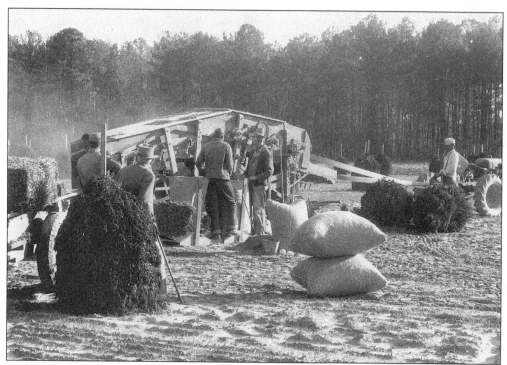

In the early 1960s the technology involving peanut harvesting dramatically changed. Prior to that peanuts were mainly harvested by what was called a peanut picker, which took five to seven men to operate as seen in this 1950s photograph.

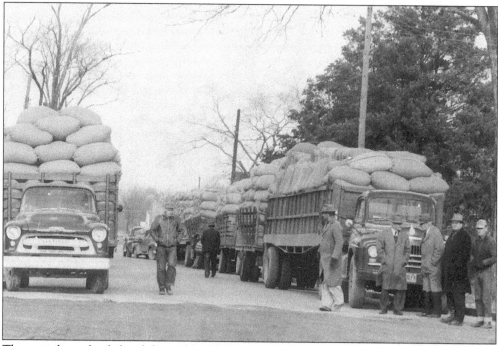

These trucks are loaded with bags of freshly harvested Hertford County peanuts waiting to leave Ahoskie for the huge peanut market in Suffolk, Virginia.

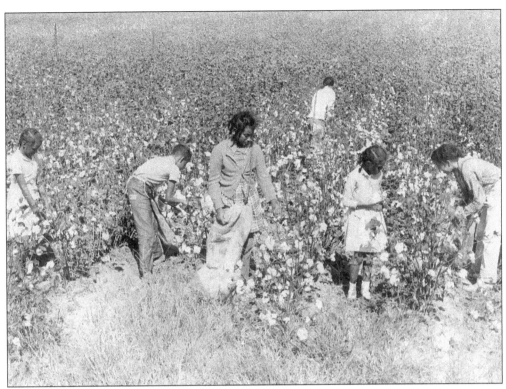

Picking cotton by hand was hard, backbreaking work. The development of the mechanical cotton picker made picking cotton by hand a thing of the past.

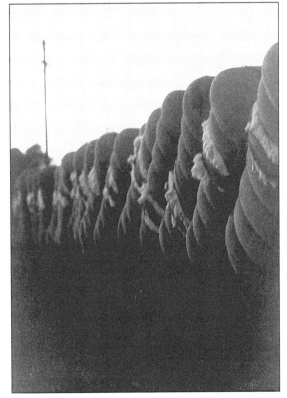

The late afternoon sun of an October day shines on a row of newly baled cotton at Revelle's cotton gin in Murfreesboro in the late 1960s.

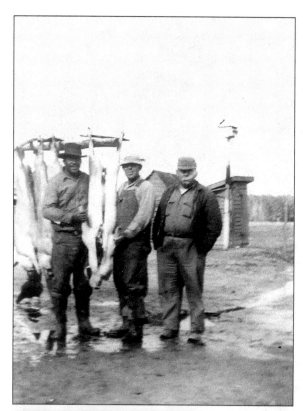

It's hog-killing time on the Ross Nichols farm in the Earley's Station community in the mid-1950s. From left to right are Bradshaw Early, Ross Nichols, and Diddly Paul Nichols.

These women are making homemade sausage using chitlins for the sausage casing. Hog-killing time was always held in January in order to keep the meat from spoiling.

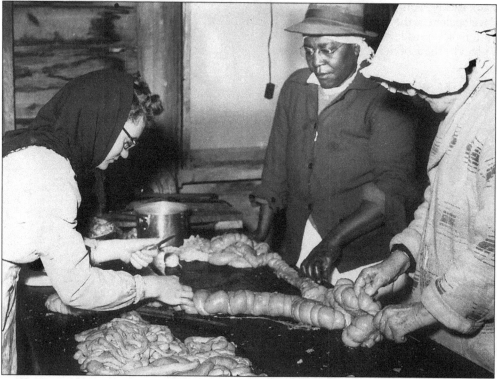

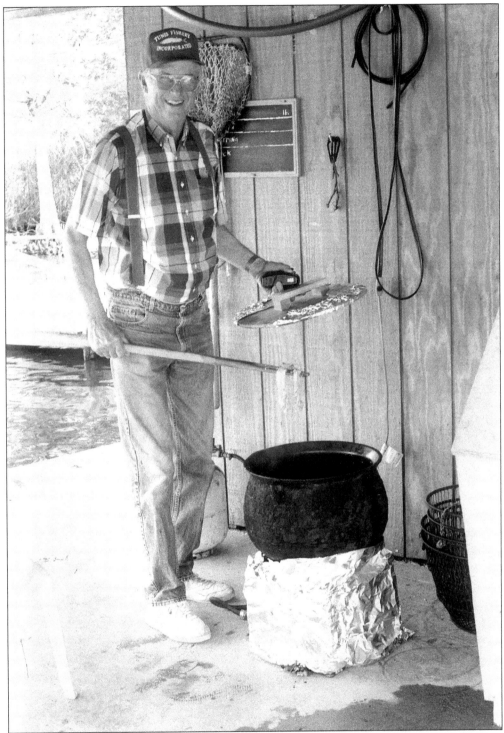

Chitlins is a Southern dish that some people eat up while others will not touch. Here Tony Stephenson is seen cooking a washpot of chitlins at Tunis Fishery. The cooked chitlins did not last long as it was readily consumed by a group of men.

A number of farmers in the county would grow sugar cane to make molasses for sale and their own consumption. This molasses mill was on the Frank Stephenson Sr. farm in the Como section of the county.

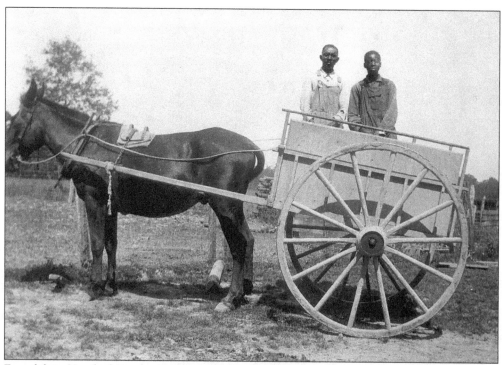

Farm life in Hertford County has progressed by leaps and bounds since the mule-and-cart days. It is a rare sight today to see a mule and cart in the county.

Eight

RIVERS OF MOONSHINE

Moonshine, or illegal whiskey, has been in Hertford County ever since European settlers moved into the region. Today there are probably several small whiskey stills operating in isolated corners of the county. But there was a time when rivers of moonshine flowed in Hertford County and making bootleg whiskey took on a way of life and culture of its own. The timeframe for the big bootleg years in Hertford County was from the 1920s through 1975 with the heyday years being the 1940s, 1950s, and 1960s, when an ocean of stump juice was produced in the county. The three key elements for a location to be good for making moonshine were a plentiful water supply, isolation, and a good overhead canopy such as holly trees. The isolation and backcountry nature of Hertford County made a perfect fit for bootleggers from within and from other locales. This river and swampy county became a mecca for moonshine operations of all sizes. Some of the whiskey stills that bootleggers set up in Hertford County were highly sophisticated while hundreds were far less complicated. A number of the stills were large-scale, capable of producing hundreds of gallons of swamp juice a week, while others would run off a jug or two with medium-size jugs rigs producing from 50 to 100 gallons weekly.

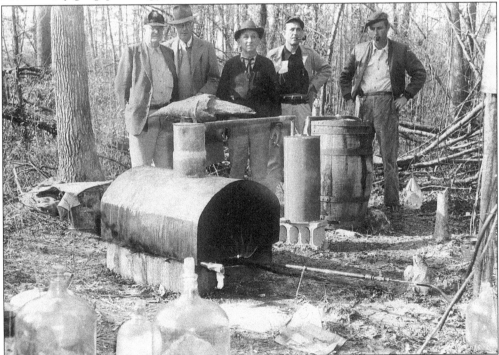

In December 1955, Hertford County moonshine raiders were photographed. From left to right, Jack Futrell, Sheriff Charles Parker, Jim Mitchell, Fred Liverman, and Livingston Sumner raided this submarine-type still near Murfreesboro

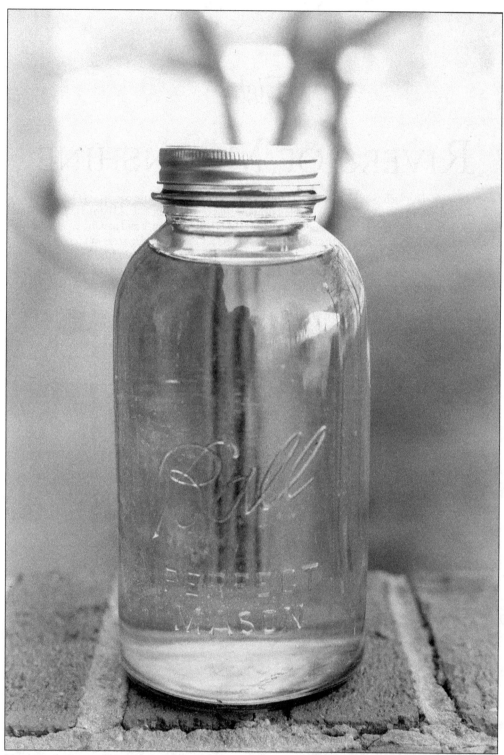

Here is a fruit jar of Hertford County's finest 140-proof moonshine.

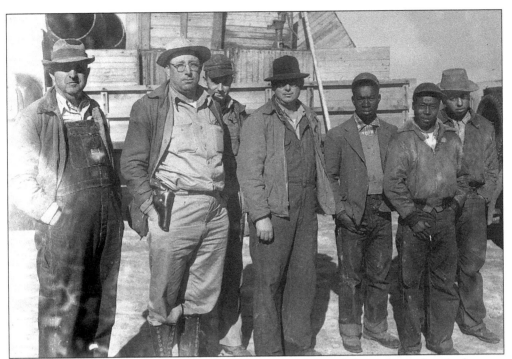

Hertford County deputy Frank Stephenson Sr., second from left, is pictured with the men who helped him raid a jumbo still in the Como section in December 1952. On the far left is L.C. Cullens and to Deputy Stephenson's left are (from left to right) Thomas Cullens, John H. Stephenson, Fred Murphy, Eddy Deanes, and Herman Wiggins.

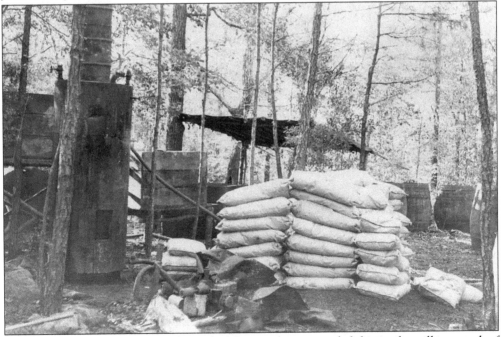

In October 1960, ATF agents and Hertford County deputies raided this jumbo still just south of Murfreesboro. Eight bootleggers from out of the area were arrested during the raid.

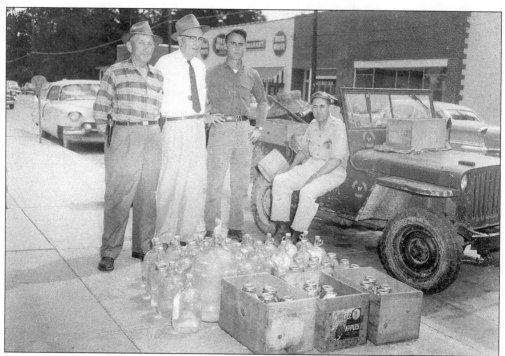

Hertford County sheriff Charles Parker (white shirt and tie) with (from left to right) deputies Jim Mitchell, James Baker, and Fred Liverman, are pictured on Main Street in Murfreesboro with moonshine they seized in a raid near Murfreesboro in April 1960.

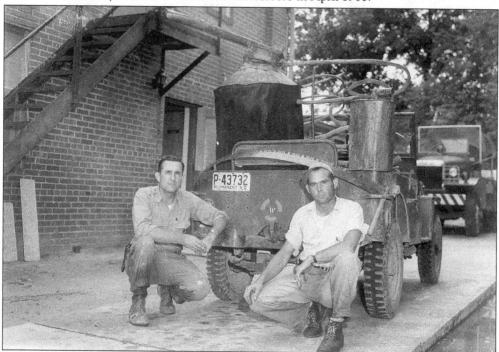

On July 16, 1958, Hertford County deputies Fred Liverman (left) and Leon Perry (right) seized this still near Cofield.

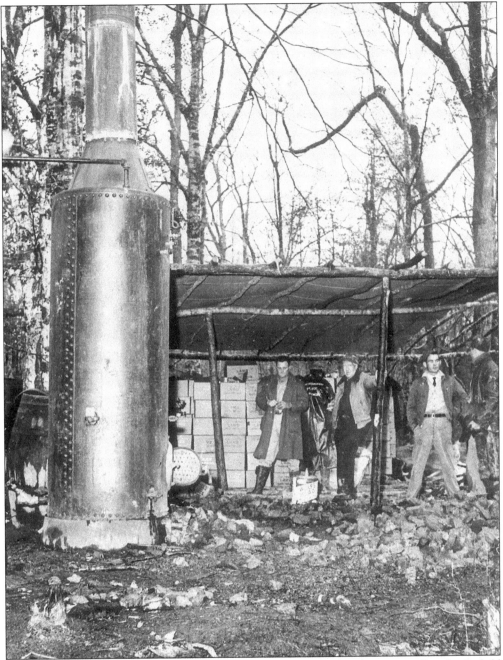

In February 1956, ATF and Hertford County moonshine raiders hit this giant still in the Cofield section of the county. When the still was raided it was billed as one of the largest found in North Carolina in recent years.

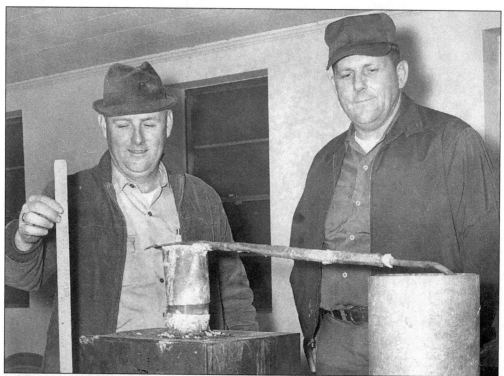

Hertford County ABC officers Livingston Sumner (on left) and Calvin Pearce examine a "giant" still they captured in the Archertown section of the county in March 1969.

Probably one of the smallest stills ever found in the region, this Lilliputian rig was raided on July 30, 1957 by Hertford County deputies Leon Perry and Fred Liverman in the Harrellsville section.

A good water supply and a rugged environment made Hertford County a haven for large and small bootleggers from within the county and other locations.

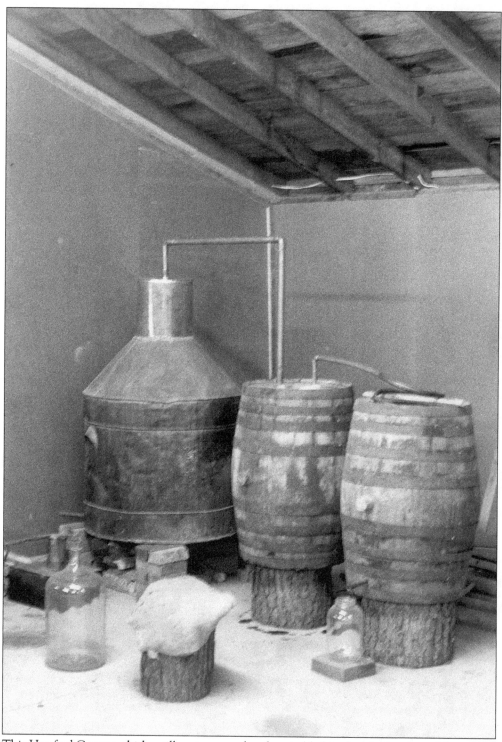

This Hertford County whisky still was captured and assembled in the Murfreesboro Museum by Calvin Pearce, a former Murfreesboro police chief and Hertford County ABC officer.

Nine

A RICH MARITIME HISTORY

At first glance one would not think that Hertford County, being so far inland, would have much if any maritime history. But it indeed did have a very rich maritime history, primarily because of the Chowan River, which forms the entire eastern boundary of the county. The Chowan River provides access to the Albemarle, Croatan, and Pamlico Sounds, Ocracoke Inlet, and thus the Atlantic Ocean. Mariners from points far and wide including Europe, New England, Southern ports, and the West Indies were attracted to Hertford County ports, wharves, and warehouses along the Meherrin, Chowan, and Wiccacon Rivers and their tributaries (such as Chinquapin, Catherine, and Potecasi Creeks). Winton and Murfreesboro were the largest of Hertford County's ports. The early mariners who made their way to Hertford County came in sailing vessels. Today about the only physical evidence remaining from this sailing era are ballast stones that can be seen at low tides at the respective ports of call in Hertford County. These grey, black, and green rocks are reminders of the locations where these hardy mariners came from Barbados, St. Thomas, St. Croix, and Grand Turk. Sailing vessels of the 1700s and the early 1800s gave way to a rich era of river steamers, large and small, transporting both passengers, commerce, and students to Murfreesboro's two colleges, Chowan and Wesleyan.

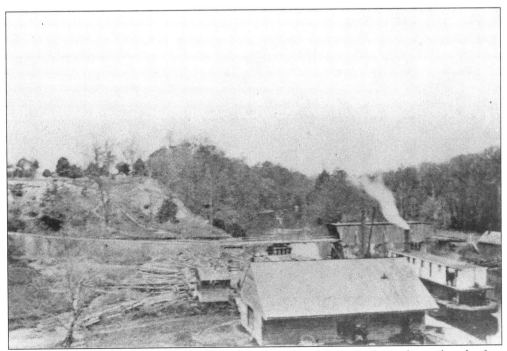

This is the earliest-known view of the Murfreesboro wharf area, which was located at the foot of Broad Street below Riverside Cemetery. This view dates *c.* 1875 and also shows the covered bridge that spanned the Meherrin River at Murfreesboro.

This is a 1900 ad for the Albemarle Steam Navigation Company, which operated steamers out of Franklin, Virginia to Hertford County ports on the Chowan and Meherrin Rivers, to Edenton, and then back to Franklin.

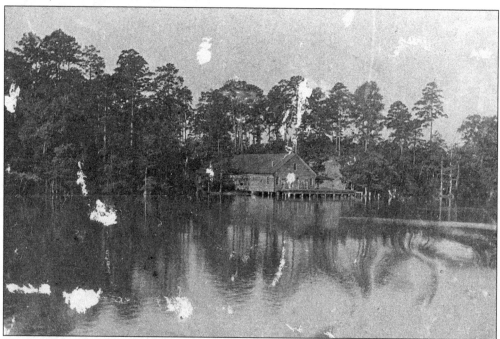

This 1875 photograph is believed to be one of the earliest-known views of the Winton waterfront on the Chowan River.

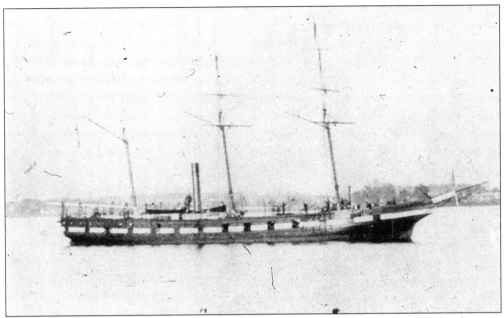

This is a photograph of the *Southern Star*, a 460-ton steamer that was built at Murfreesboro on the Meherrin River. It was launched at Murfreesboro on April 16, 1857. The launch of the *Southern Star* was such a big event that the presidents of Chowan College and Wesleyan Female College respectively dismissed classes so that their students could attend the launching. The ship was later acquired by the United States Navy and renamed the USS *Crusader*.

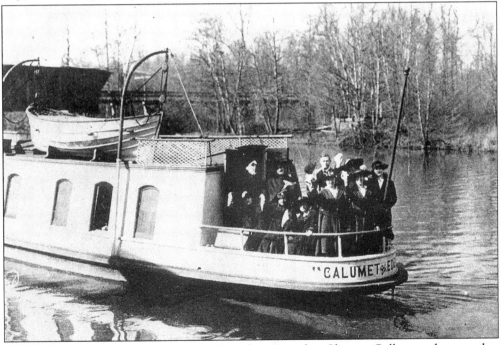

The steamer *Calumet* was just one a number of steamers that Chowan College students used to get to Murfreesboro. This photograph is from the 1918 Chowan College yearbook and shows the Murfreesboro covered bridge in the background.

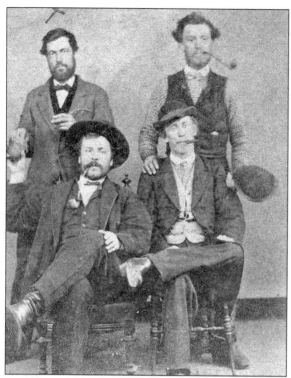

This 1880s photograph shows Capt. Thomas I. Burbage, top left, and his steamship crew. Captain Burbage operated a number of steamers for the Albemarle Steam Navigation Company on the Chowan and Meherrin Rivers.

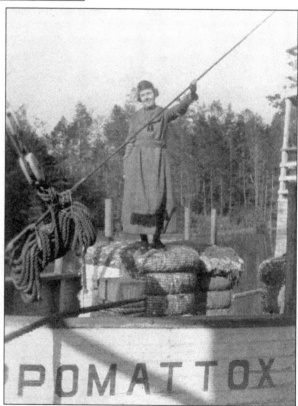

Here is a 1920 view of the steamer *Appomattox* docked at Murfreesboro. The passenger is standing on a bale of cotton.

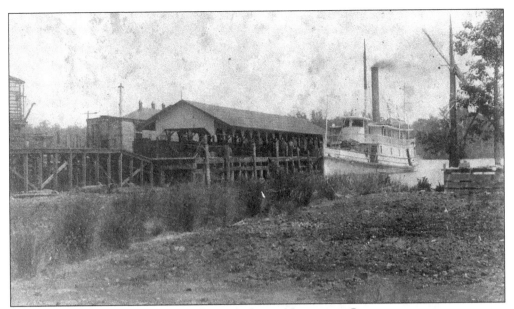

This photograph of the *Olive*, an Albemarle Steam Navigation Company screw-type steamer, was taken in late 1902 at the Tunis wharf. The Atlantic Coast Line railroad station at Tunis is seen to the left. Shortly after this picture was taken the *Olive* was hit by a tornado and sunk below Colerain on the evening of February 16, 1903. Seventeen passengers lost their lives in the disaster. The *Olive* was salvaged, rebuilt, and returned to service as the *Hertford*.

The sinking of the *Olive* and the loss of 17 lives was indeed big news in its day, and needless to say, many stories were told about it and its passengers down through the years. One such story involves a young female passenger from the Christian Harbor section of Hertford County. Engaged to be married, the young woman was on the *Olive* on her way to Edenton to pick up her wedding dress when she was killed. Her fiancé drove a spiral rod and a second metal rod from the *Olive* into her grave to mark its location. The two metal grave makers can be seen today at the young woman's grave site in the Christian Harbor cemetery.

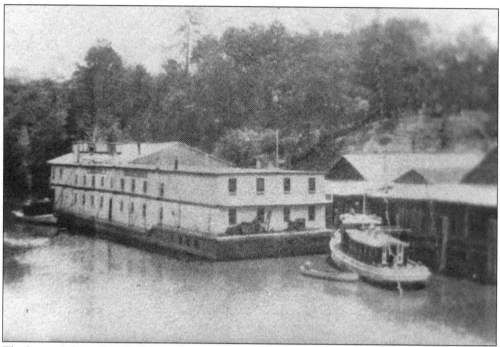

The James Adams Floating Theater is shown here docked at Murfreesboro in 1923. This floating vaudeville theater was the inspiration for Edna Ferebee's Show Boat and it made a number of trips up the Chowan and Meherrin Rivers to Hertford County ports.

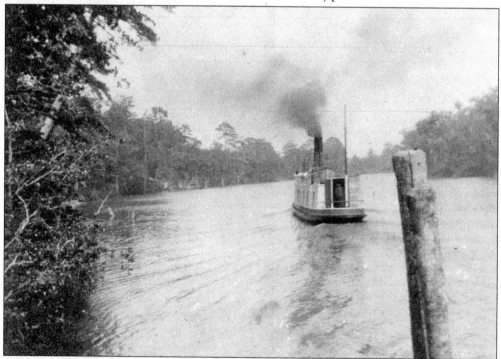

The steamer *Calumet* is seen in this 1912 photograph heading south on the Meherrin River. The steamer carried mail between Murfreesboro and Edenton.

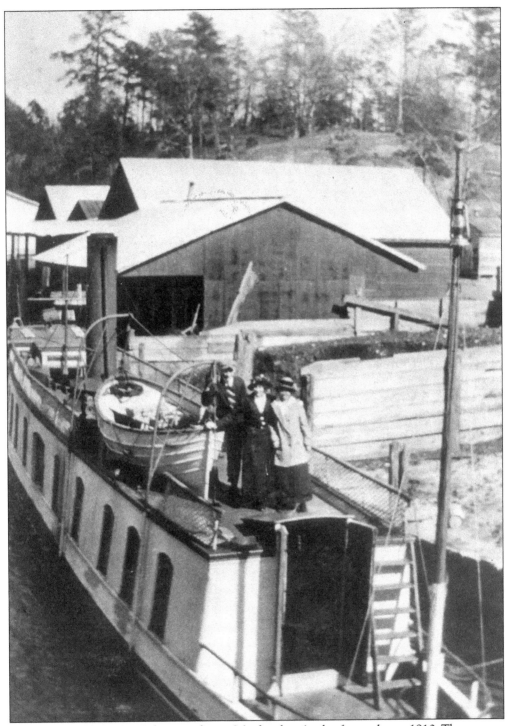

This view of the steamer *Calumet* tied up at Murfreesboro's wharf was taken *c.* 1910. The steamer is actually docked next to the coal bin where steamers took on coal.

The Como wharf was one of a number of warehouses along the Meherrin and Chowan Rivers where river steamers stopped.

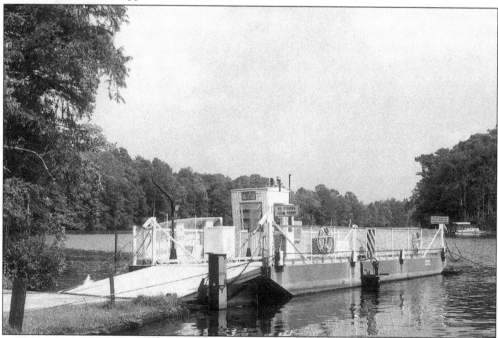

Parker's Ferry, which crosses the Meherrin River between the Winton and Como sections of the county, is one of three such river ferries remaining in North Carolina. Hertford County, with its many rivers and creeks, had a large number of small ferries similar to this operating for many years.

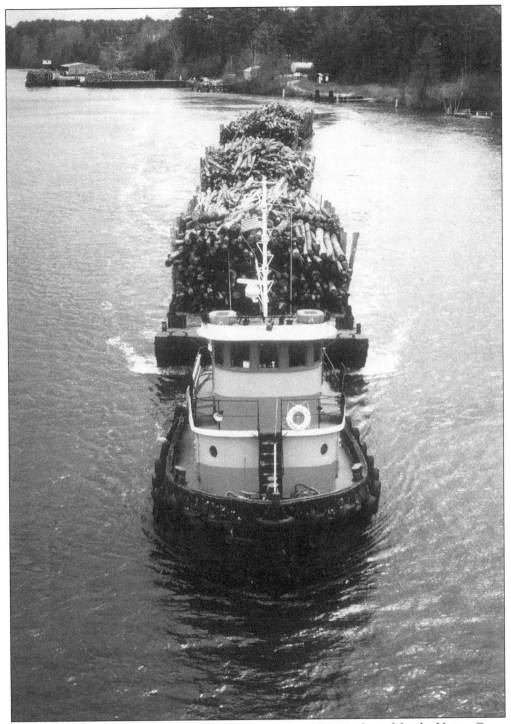

The tug *Tuscora* is seen pulling a load of pulp wood out of Winton bound for the Union-Camp paper mill on the Blackwater River at Franklin, Virginia. When Union-Camp Corporation merged with International Paper, the Marine Operations was closed and the existing tugs and barges were sold.

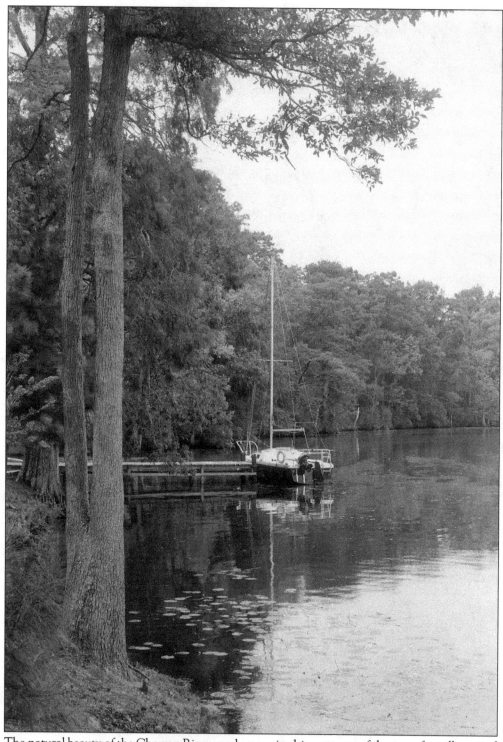

The natural beauty of the Chowan River can be seen in this very peaceful scene of a sailboat tied up on the upper Chowan River, in the Como section of northern Hertford County.

Ten

A Place in the Heart

Hertford County is colonial roads, Indian paths, Indian village sites, mistletoe, watermelons, cane-pole fishermen, the Gatling gun, sassafras tea, rabbit, quail, mothers, holly, magnolia, reeds, and mulberry trees. Hertford County is children, dogwoods, crepe myrtles, traditions, folklore, myths, legends, handblown glass, pines, peanuts, herring, corn, tobacco, chitlins, grits, Roy Johnson's books, cotton, college students, old cemeteries, cypress, junipers, country cured ham, sweet potatoes, rivers, creeks, wide yellow pine flooring, lily pads, day lilies, churches, fisheries, a river ferry, 18th- and 19th-century architectural masterpieces, white oaks, molasses, moonshine, and cattails. Hertford County is lye soap, corned herring, frog legs, apple pie, shutter dogs, box locks, pecans, gracious hospitality, cypress knees, herring fisheries, juniper water, wild rivers, arrowheads, pounding stones, Indian pottery, pigtails, scuppernongs, pears, peaches, apples, wild turkey, bears, crab apples, collards, cabbage, crows, deer, classic columns, sandy river beaches, archaeological sites, revolutionary patriots, catfish, tadpoles, farmers, the fragrance of spring, the heat of summer, the painting of autumn, and the lean days of winter. Hertford County is the simple joy of a wildflower, the serenity of a quiet riverbank, daisies, sunflowers, daffodils, witch-hazel, milkweed, duck potatoes, open spaces, pumpkins, walnuts, hickory nuts, wild grapes, blackberries, plums, persimmons, Spanish moss, friendship, understanding, and our homeland—a place in the heart.

Here is a slave cemetery on the Thad Vann in the Como section.

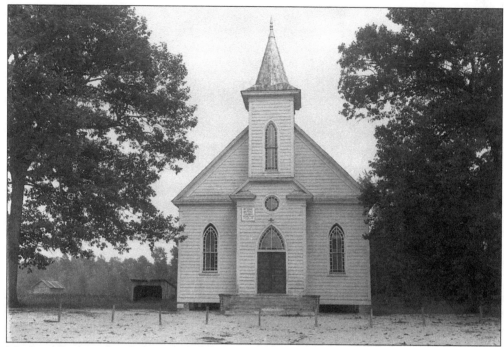

Mt. Sinai Baptist Church, located on the Boone's Bridge Road in the Como section of Hertford County, has been serving African-American worshippers since 1882. The church began as a "brush arbor" place of worship for former slaves, their children, and a few Native Americans. Rev. Andrew Hill was its first pastor. Rev. Franklin Lee is the current minister at Mt. Sinai.

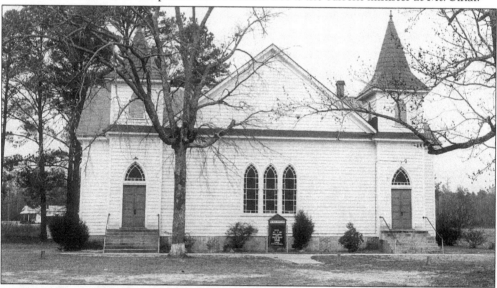

In the northeast section of Hertford County not far from the Virginia-North Carolina state line stands Mill Neck Baptist, a place of worship for African Americans since 1866. Rev. William Reid was the founding minister for the church, which like Mt. Sinai Baptist Church had its beginning as a brush arbor. Dr. H.L. Mitchell had a long and distinguished service as a minister at Mill Neck Baptist Church. Dr. C.S. Brown and Rev. James A. Felton also rendered distinguished service to the church as ministers.

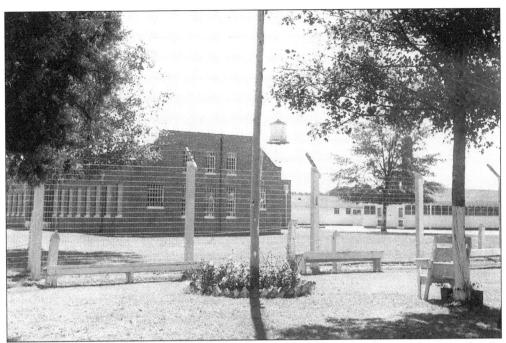

In August 1967, the closed North Carolina prison unit at Union in Hertford County officially became a member of the North Carolina Community College System as Roanoke-Chowan Community College. It serves the citizens of the Roanoke-Chowan region of North Carolina.

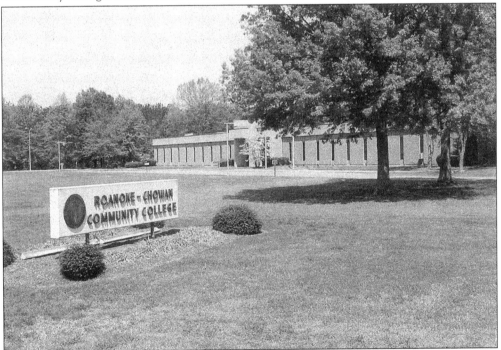

Roanoke-Chowan Community College, located approximately three miles from Ahoskie in Union, has experienced impressive growth since its founding in 1967. The college has a 41-acre campus comprised of four modern classroom buildings and several other buildings.

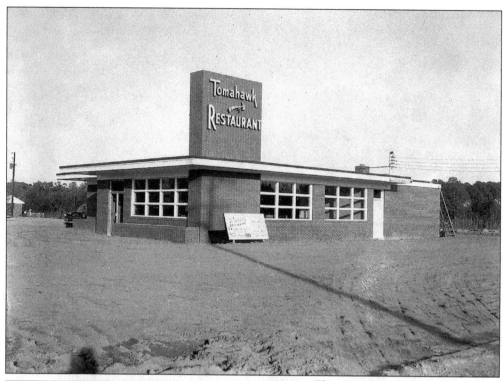

This is a 1954 photograph of the newly completed Tomahawk Restaurant, a favorite eatery in Ahoskie for many years.

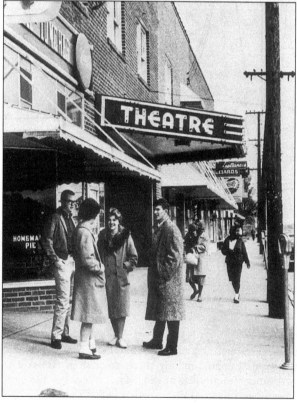

Murfreesboro's Pastime Theatre provided entertainment for moviegoers for nearly 40 years. Tex Ritter, Lash LaRue, and lady wrestlers were some of the stage acts that performed on the Pastime's stage.

Calvin Scott Brown Regional Cultural Arts Center and Museum in Winton was established in the 1980s to promote and preserve the multi-ethnic heritage of the region. Its named in honor of Dr. Calvin Brown who in 1886 founded Chowan Academy, an educational institution for black children. The Center's building, Brown Hall, was built in 1926 and was the last building built by Dr. Brown as a part of Chowan Academy.

In 1854, as a little boy, Dr. Walter Reed lived here with his father who was a Methodist minister. Dr. Reed was nationally known for his work in eradicating typhoid and yellow fever. The Walter Reed Army Hospital in Washington, D.C. bears his name.

Since 1917 one of the stalwarts of the Hertford County community of Earley's has been Earley's Baptist Church. The Atlantic Coast Line Railroad at one time had a station in Earley's.

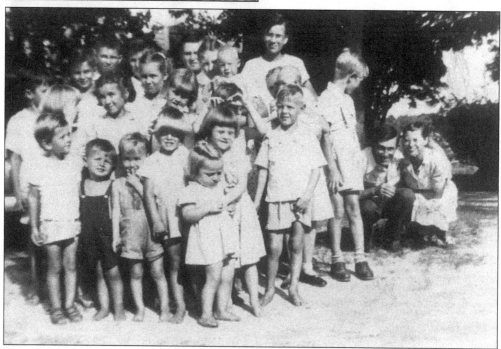

On July 4, 1948, the grandchildren of Alonso and Cora Marvin Brantley Nichols of the Earley's community gathered for this photograph.

In 1955, the North Carolina Historical Commission erected this highway marker on the Ahoskie school grounds to commemorate the founding of the 4-H Clubs of North Carolina in 1909 by Dr. T.E. Browne of Murfreesboro.

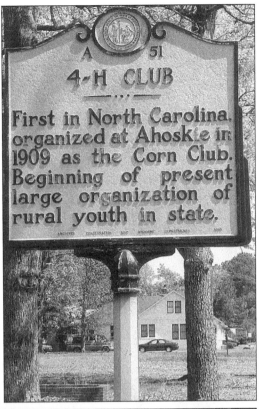

In June 1959, a celebration was held in Ahoskie commemorating the 50th anniversary of the founding of the 4-H Clubs in North Carolina. The principal speakers for the occasion were Dr. Gilbert T. Stephenson, a bank executive, and L.R. Harrell, state 4-H Club leader. Miss Audrey Holloman of Harrellsville was named Miss 50th Anniversary Queen of the North Carolina 4-H Clubs.

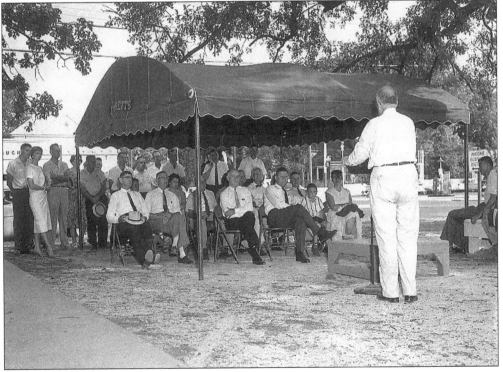

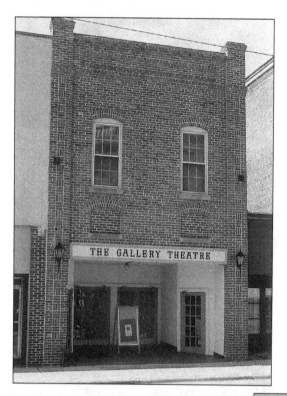

In 2003 the Gallery Theatre in Ahoskie will celebrate its 37th year of operation after turning the former Richard Theatre into a cultural centerpiece for the region. First-rate live stage performances of all types and other activities are held here.

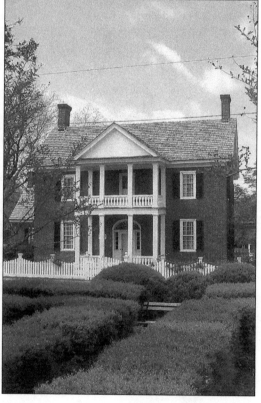

The restored 1810 John Wheeler house is the signature restoration in Murfreesboro's extensive and highly successful historic preservation program. The house is the birthplace of John Hill Wheeler, a legislator, superintendent of the United States mint at Charlotte, and the first United States minister to Nicaragua.

Bethlehem Baptist Church was established in 1835 on land given by Abraham Thomas and his wife. The present church building, built in 1906, is the third to be erected on this site. The church is located in the Bethlehem community between Ahoskie and Harrellsville.

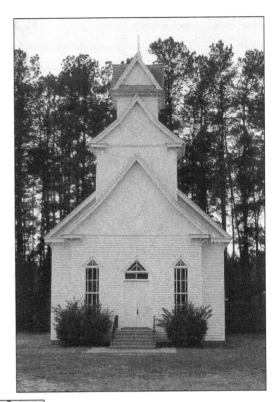

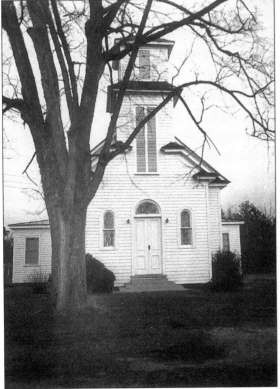

Union's Methodist Church has been a beacon of strength in the community for over 100 years. One of its members years ago was Richard Jordan Gatling, inventor of the Gatling gun. At that time Gatling was a store keeper at nearby Frazier's Crossroads.

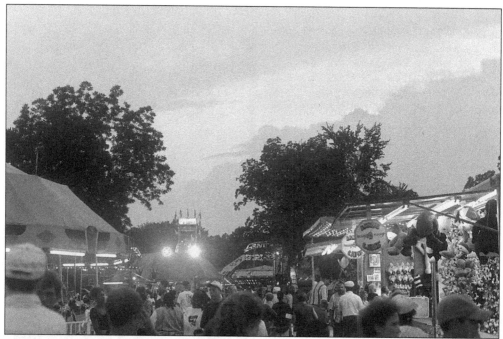

The North Carolina Watermelon Festival is one of a number of festive events held in Murfreesboro annually. The Harvest Tour, Ghost Walk, Candlelight Christmas, and the Roanoke-Chowan Pork Fest are some of the other events that residents and visitors enjoy.

The Hertford County community of Mapleton is the site for the annual Darden Family Bluegrass Festival and Picking Party, featuring first-class bluegrass entertainers and music. Now in its 13th year, the festival is hosted by the Darden family from which former Virginia governor Colgate Darden is descended.

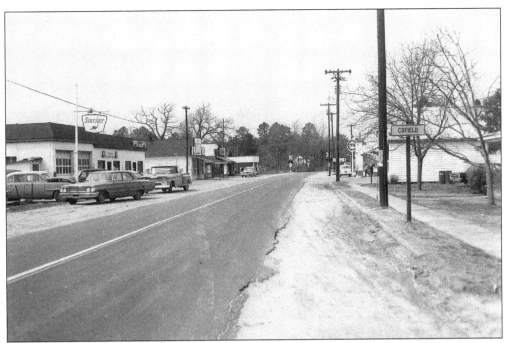

Here is a 1960s view of Cofield's Main Street. In its early years, Cofield was a railroad community with strong ties to Winton, Tunis, and South Tunis.

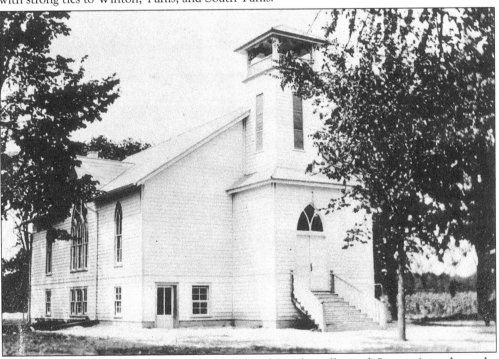

This is a 1920s view of Buckhorn Baptist Church in the village of Como. As early as the 1730s an Anglican chapel was built here by James Maney. After the Revolutionary War, the Anglican chapel gave way to an Episcopal Chapel and in 1835 Buckhorn Baptist Church was established here.

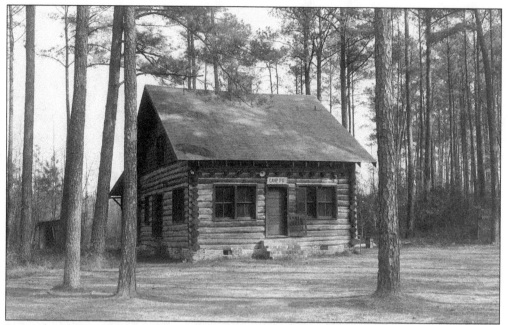

Located in the Big Woods section of Como, Camp P.D. Hunt Club is the oldest chartered hunt club (1881) in North Carolina. The hunt club was established by members of the Camp family of Franklin, Virginia.

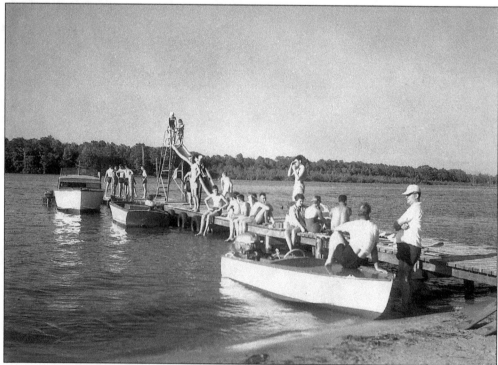

Tuscarora Beach, located on the Chowan River between Winton and Tunis, was a favorite beach playground for many years. In the 1920s and 1930s power boat races were held here. In the early years this was the location for Barfield's ferry and a huge herring haul seine.

Clarence Parker's County Store Museum in Menola was always a big hit for visitors. An avid collector of country-life artifacts, Clarence Parker saved many examples of early farm life from destruction. Many of the farm-life artifacts can be seen on display in the Winborne Country Store and Law Office Museum in Murfreesboro.

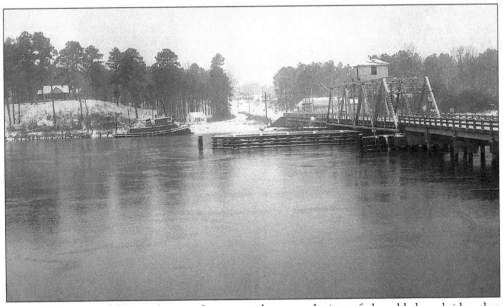

This 1950s view of Winton's waterfront provides a good view of the old draw bridge that spanned the Chowan River between Hertford and Gates Counties. One of Camp Manufacturing Company's tugs can be seen docked at the Winton pulpwood loading docks.

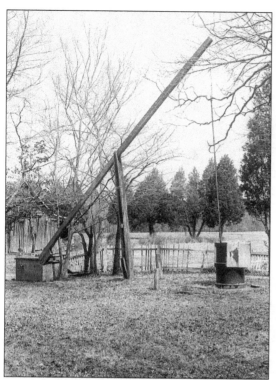

A survivor from years past, this well sweep still stands on the Thad Vann farm in the Como section of the county.

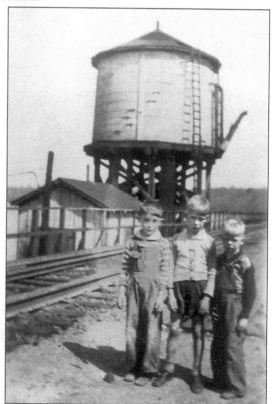

In 1945 these three cousins, (from left to right) Frank Stephenson Jr., Lloyd Bittle, and Frank Bittle, gave the Tunis train station a thorough going over.